December
2004

Happy Trails Margy!

xx

Pamela

A FIELD OF HORSES

The World of Marshall P. Hawkins

◇

THE DERRYDALE PRESS

FOXHUNTERS' LIBRARY

A Field of Horses

THE WORLD OF MARSHALL P. HAWKINS

JAMES L. YOUNG, M.F.H.

Foreword by Jacqueline Kennedy Onassis

THE DERRYDALE PRESS

Lanham and New York

Published by The Derrydale Press
 4720 Boston Way
 Lanham, MD 20706

Distributed by National Book Network.

Library of Congress Cataloging-in-Publication Data

 Young, James, 1941-
 A field of horses: the world of Marshall P. Hawkins / Photographs
 by Marshall P. Hawkins; text by James L. Young; introduction by
 Jacqueline Kennedy Onassis.
 p. cm.
 ISBN 1-58667-095-6
 1. Horses—Pictorial works. 2. Photography of horses.
 I. Hawkins, Marshall P., 1910- . II. Title.
 TR729.H6Y68 1988
 779'.32—dc19 88-12304
 CIP

Printed in the United States of America

Designed by Walter Gray Lamb

To my wife, 'Cela, who has improved many of my photos by her hand-painting,
and to my three children:
Joan, T.L. (Thomas), and Marsha Lynn.

—M.P.H.

To my grandson, Stirling Harrison Young, Jr., and
to my two sons, Stirling and Rob, all of whom I wish
the same happiness I have had with horses and family.

—J.L.Y.

Try Back: A Re-Introduction

It is a singular tribute to Marshall Hawkins that the renowned sporting publishing house, The Derrydale Press, has chosen to reprint *A Field of Horses*. Reviewing this book of Marshall's lifelong work after fourteen years, I am still in awe of the timelessness of his artistry. That makes Derrydale's commitment all the more complimentary. I'm proud to be a part of the process.

Jackie Onassis was particularly taken with this project. She first came to know Marshall when he photographed her having a fall while hunting with the Piedmont Fox Hounds (p. 19). The picture of the first lady soared around the world and made Marshall's career. Afterwards, not only did she provide the eloquent foreword, but she graciously provided editorial expertise when I struggled to make final decisions about which photos to include. A respected editor for Doubleday Books, Jackie spread the photos across my library floor. I will treasure the memory of her in boots and breeches as she selected and rejected the last photos from the batch arrayed on the rug before her. Her instinct was spot on and her taste exquisite.

After receiving her copy she wrote, "It's glorious! Glorious! Everyone will be giving it for Christmas!" She really cared about this small endeavor, and she made it better.

Many have asked, so I am pleased to report that Marshall Hawkins did see and enjoy the belletristic fruit of his lifelong passion just before he died. He was very ill when the book was in the final phases of publication, but I was able to bring the first copy to him in the hospital. He went page by page through the book and identified every picture.

Then he was wheeled to x-ray, his arms folded around the book. That was the last time I ever saw Marshall alive.

Later, a devout local lady, Dorothy Rust, told me a story. Dorothy often spent time at the hospital reading to patients and doing Bible study with them. She had been reading to Marshall chapters from Zechariah in which an angel of the Lord speaks to Zechariah about men riding red, speckled (bay) and white horses amongst myrtle trees. When Zechariah asks what are these, he is told that they are they whom the Lord has sent to walk to and fro upon the earth. "And they answered the angel of the Lord . . . and said, We have walked to and fro through the earth and behold, all the earth sitteth still, and is at rest."

Soon thereafter Dorothy was driving down a winding road outside Warrenton on the way to the hospital when she was confronted with three horses which had escaped a nearby pasture. A caring horsewoman, she stopped her car and gently herded the animals to safety off the busy road onto a lawn where they began to graze. Soon the owner appeared and returned the three horses— a chestnut, a bay and a gray—to his nearby farm. Dorothy continued on to the hospital where she learned that Marshall had died earlier that morning.

The lawn upon which the three horses peacefully grazed belonged to Lucille and Marshall Hawkins. "All the earth sitteth still, and is at rest."

James L. Young, MFH
The Plains, Virginia

Contents

Foreword

Marshall Hawkins' book of equine photography is an archive of countryside images that stirs the echoes of a simpler, vibrant sporting life. The inexorable press of modern development has steadfastly reduced the perimeters of our natural environment, not just for horsemen, but for nature-lovers all. Everywhere we look, we are reminded of the countryside which once was, and we wish for earlier times.

For over fifty years, Marshall has caught the poetry of man and horse in harmony with their natural surroundings. As we see them move together across his exquisite landscapes, we are made aware of our responsibilities to preserve and conserve the simple splendor of a vanishing America.

Rich in detail and scope, Marshall's photographs are personal keepsakes for his subjects — intensely felt, vanished moments now fixed forever. But their value is far beyond the personal; they reveal a treasure of natural heritage — human, equine, and rural.

JACQUELINE KENNEDY ONASSIS

Introduction

The silhouette is recognized by thousands of horsemen: feet in a boxer's stance, one slightly ahead of the other; body bent forward at the waist; the shoulders hunched, supporting a head whose face is obscured by the camera; the camera seeming to support a Tyrolean fedora with a pheasant hatband. The dean of American equine photography, Marshall P. Hawkins, is as recognizable as the spires of Churchill Downs, as familiar as the clarion call to the post. He is provided automatically with press passes to all the major horse events from New England to Florida and west to St. Louis, and only his advanced age now curtails the radius of travel from his home in Warrenton, Virginia.

We Americans seem always to have been obsessed with our images. Long before George Eastman produced his first roll-film camera in 1888, the affluent of this land provided livelihoods to countless portraitists in their attempts to secure a sense of permanence, even immortality, to their lives. With the arrival of Mr. Eastman's invention, popular photography evolved to satisfy our individual and collective appetites for immediate pictorial gratification.

Over the course of fifty years of professional photography, Marshall Hawkins has produced pictures of incomparable mastery. The trick for the commercial photographer, of course, is to meld the artist's aesthetic expectations with the subject's personal expectations so that what is produced is personally pleasing and commercially viable. Hawkins' products are eminently viable; he has made a good living at it since 1934. Trying to describe what makes it so is like trying to define the allure of Elizabeth Taylor, the charisma of Babe Ruth, or the grace of Fred Astaire. The sum of the parts just refuses to add up to the finished product.

Hawkins must be doing something right, because he has clients of fifty years' standing. He has been flown about the country in private and commercial planes to photograph family horses, hunts, and weddings. He is recognized and welcomed in the social sandboxes of Palm Beach, Saratoga, and Middleburg. Yet he lives in a modest home outside Warrenton, eats at a nearby steak-and-fries diner, and patronizes the local picture processing service. The master of modern horse photography is a guileless working man who confronts life, friends and foes alike, head on. He is fiercely loyal to and protective of those who have befriended and supported him, and he has a long memory for duplicitous sycophants. He, like his pictures, is without artifice.

For two and a half years I have lived with the vestiges of The Hawk's professional life, in anecdotal and pictorial form.

His photographs occupied my dining room to the extinction of any formal entertaining, and each picture could elicit a fifteen-minute narrative as to its inception. Being an ersatz historian who knew many and loved all of the characters and stories behind each picture, I began to equate myself with the mythical figure Tantalus. My thirst for the project's end might never be slaked, especially with the prospect of reviewing more than 15,000 prints. And Marshall had 300,000 *more* stacked to the ceiling in a room at home!

We persevered, however, and with my wife's forbearance, there was an occasional dinner party. During that two and a half years, moreover, I gained some salient, and some not-so-salient, insights into the Hawkins phenomenon. First of all, I learned that nearly *everyone* is waiting for a picture Marshall has promised. To the 173 persons who asked me to look out for a particular photo once promised — I didn't see it. But Marshall remembers it, and it's on its way! Second, Hawkins at seventy-seven sustains an astounding memory. If we looked at 15,000 pictures, he could remember at least one person in every photo, where it was taken, when it was taken (give or take a few years), and detailed anecdotal information on the horse, rider, rider's family, the fence, or the weather.

Speaking of the pictures' contents, a word about the captions may be in order. From the start, I intended the thrust of this book to be more than a snapshot album. I saw it as a showcase for Marshall's formidable accomplishments in equine photography. In other words, the photographs should stand on their own merits. The teacher in me, moreover, envisioned the captions as a means to educate, elucidate, and entertain. Considerable effort was made to correctly and precisely fulfill the who, what, where, and when dimensions, but given the exigencies of a half-century of material and the frailties of memory, some captions may be less than exact, even incomplete. In addition, there were pictures we hoped to include that ended up on the cutting room floor. To those whom we led to believe might be included, please understand that some very difficult choices had to be made.

A Field of Horses (the title alludes to the photographic field of the camera) is an insufficient summation of a man's professional life. How can one distill fifty years of varied career into the space of 192 pages? It cannot be done adequately, and so, in the tradition of the movie *Rocky*, watch for the sequel.

JAMES L. YOUNG
THE PLAINS, VA.

I

Foxhunting

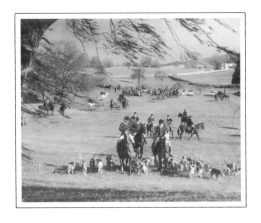

◇

"Foxhunting is not merely a sport — and it is more nearly a passion than a game. It is a religion, a…faith. In it are the elements that form the framework upon which beliefs are built: the attempt to escape from life as it is [to] a life as we would have it; an abiding love of beauty; and an unconscious search for the eternal verities of fair play, loyalty and sympathetic accord, which are so clouded in our mundane existence."

MASON HOUGHLAND, M.F.H.
GONE AWAY, 1933

The splendor of the foxhunting field has for many years attracted and inspired Marshall Hawkins. Any one of this myriad hunting scenes presents a microcosm of his skills. Everything in the frame, be it horse, hound, huntsman, or homeplace, appears in detailed focus — no matter how far scattered. Though foxhunting takes place in the stark nakedness of winter, Hawkins' trees and landscapes and sky (Marshall embraces the sky!) act as contrapuntal melodies in the symphony of his compositions.

His shutter clicks and the curtain opens onto a diorama of characters, each with a starring role in the script, each with an instantly drawn persona. The foxhunting pageant is populated with participants who are meticulous to the point of obsession about their images. Horses' ears must be pricked forward, habit and tack impeccable, and expressions (human and equine) rife with exuberant dignity. And while many foxhunting photos tend to focus on one person, often one in the lead, the group shots provide a study in character. The foxhunting personality can be, variously, elegant, daring, proud, frightened, arrogant, pleased. Study the faces, for Hawkins' foxhunting pictures can provide a rich panoply of portraits.

Hawkins' pictures satisfy both our snapshot mania and our quest for the immortality of a portrait. So what if a client is only one in the field? The scene and the characters, the form and color, the uniqueness of his works, fairly take one prisoner and provoke demands of "I must have this one!" Oil portraits are expensive nowadays; one cannot have too many Hawkinses on the walls.

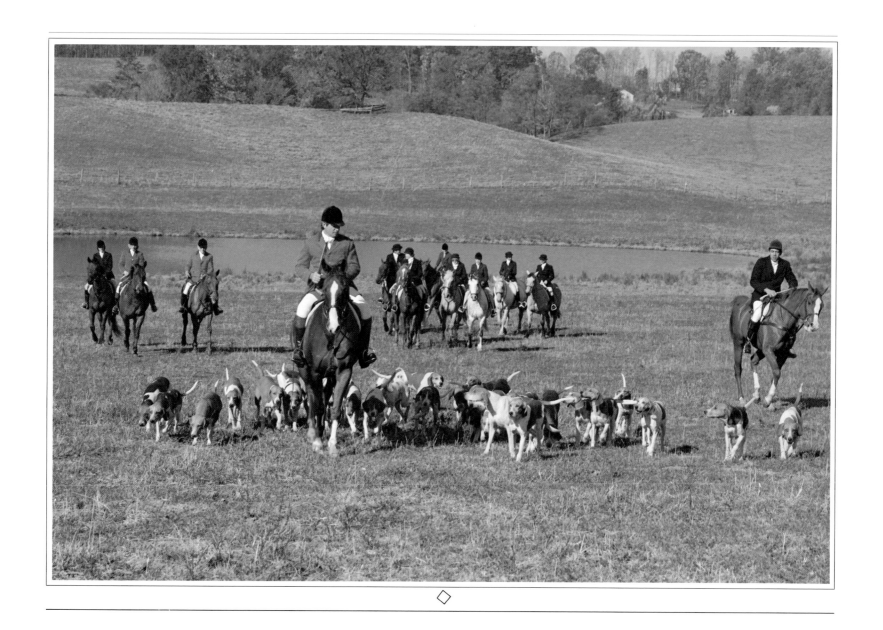

Casanova Hunt (Virginia) huntsman Tommy Lee Jones, in the foreground; behind, in "pink" coats, so named for a legendary London tailor, are Joint-Masters Gretchen Stephens and Col. Samuel Richards. On the white-faced chestnut horse at the right is longtime whipper-in Melvin Johnson.

The attentive and disciplined Piedmont Hunt hounds await huntsman Albert Poe's word to move off. Charlie Kirk, whipper-in and, later, huntsman, is at right.

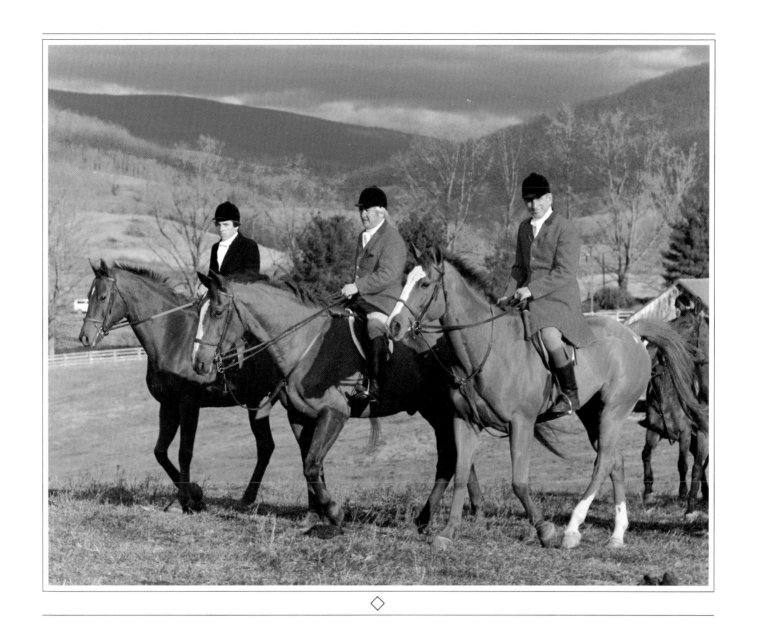

◇

*Rappahanock Hunt Joint-Masters hunting in 1984: (right) the late
Bernhard Dahlgren and (center) Larry LeHew. LeHew's son, Jeff, is
on the far left.*

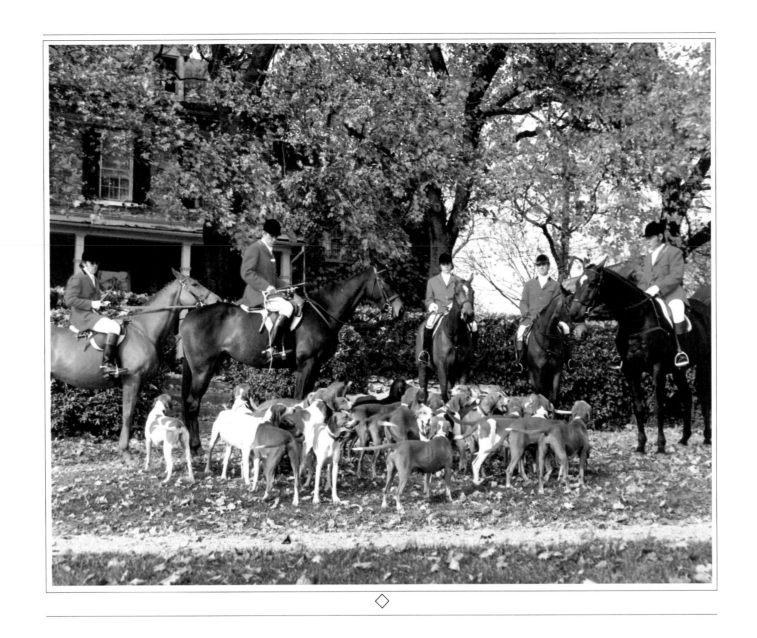

A meet of the New Market Hounds with Master and huntsman
Gilmore R. Flautt III (second from left) and members of his field
in the 1970s.

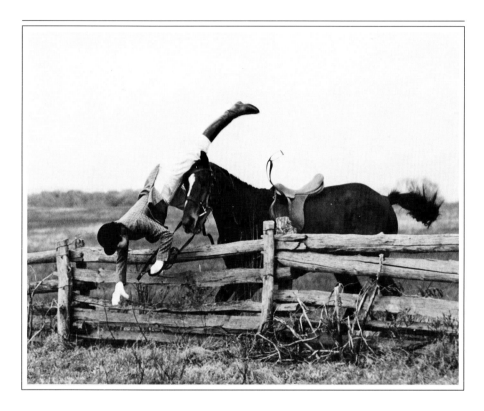 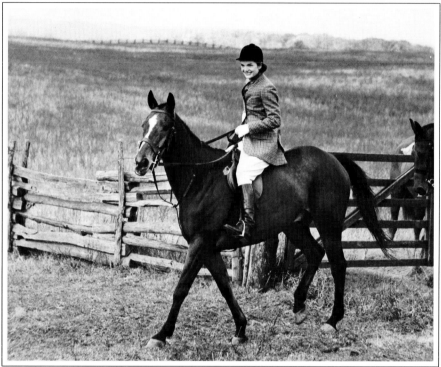

In 1962, Marshall's instinct for placing himself advantageously allowed him to capture then First Lady Jacqueline Kennedy as she was catapulted over a fence while foxhunting with the Piedmont Hunt near Upperville, Virginia. Sensitive to the family's sense of privacy, Hawkins sought Mrs. Kennedy's approval to publish the picture. Both she and President Kennedy graciously assented and Life magazine won the American publishing rights. Hawkins became internationally known when the London Daily Express bought the world rights.

The second picture was included in the Life magazine spread as an assurance that the first lady was not hurt and that, indeed, she remounted and with a smile continued to hunt. Like all foxhunters, Mrs. ~~Kennedy has~~ had her share of falls while foxhunting, but she is a fit and keen athlete who is not deterred by mishap.

Caroline Kennedy Schlossberg galloping on a run through James Strother's Texas Farm while hunting with the Orange County Hunt in 1986. Caroline carries a leather case attached to her saddle that contains a tin for a sandwich and a glass flask for some non-carbonated drink, such as fruit juice. The horse's activity in the hunting field would cause a carbonated drink to explode.

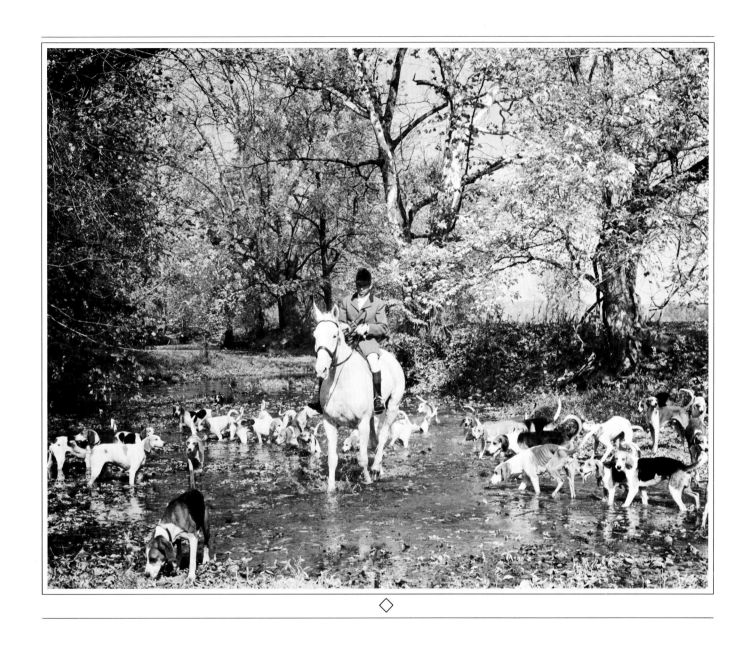

◇

*Former huntsman Cash Blue refreshes his Casanova Hunt pack in
a rewarding creek after a hard run near Auburn, Virginia.*

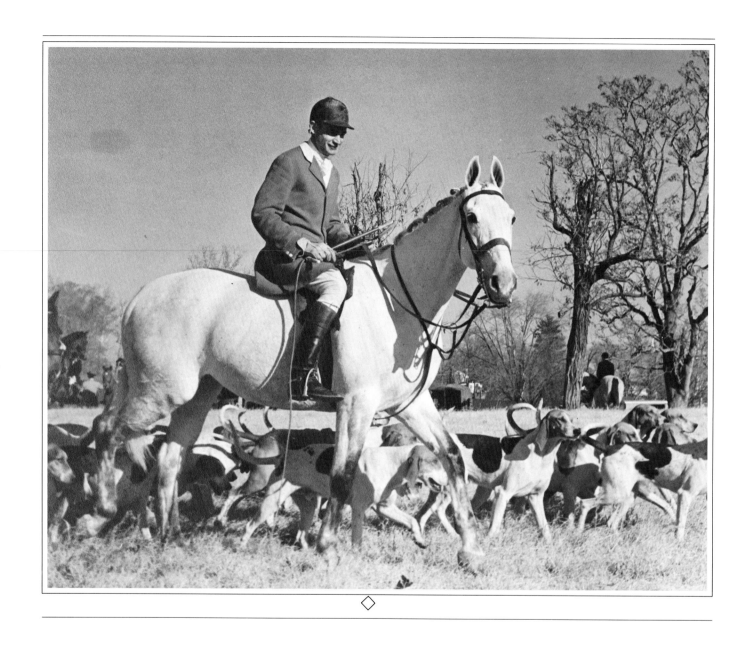

Warrenton huntsman for thirty-five years, Hugh "Dick" Bywaters and the pack of the Bywaters strain of American hounds. Dick's grandfather Burrell Frank Bywaters was a seminal breeder of hounds during the first two decades of this century. Sadly, this strain of American hounds has all but disappeared.

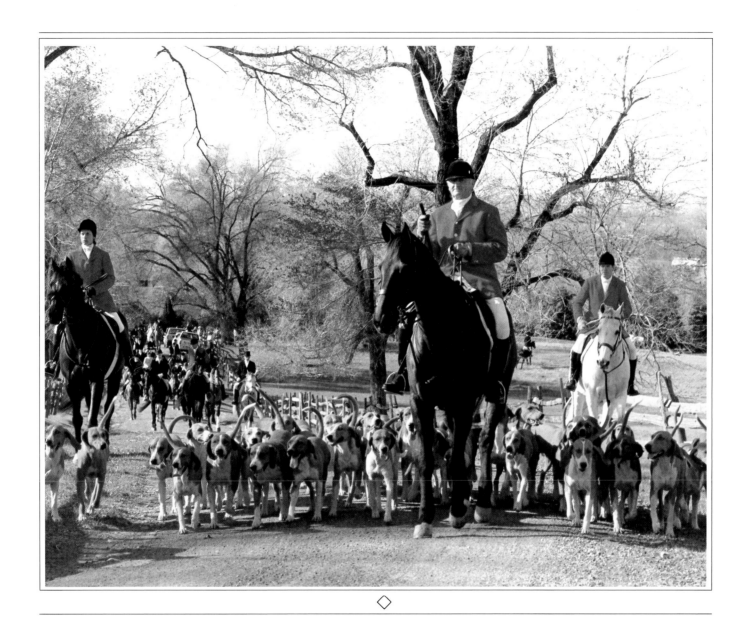

◇

The Orange County Hunt hacking from a meet to draw the first covert (a likely fox lair). In the center is Melvin Poe, OCH huntsman for twenty-five years. On the left is professional whipper-in Christine Gray, Poe's stepdaughter. Her mother served as whip before her. On the right, John Coles, honorary whipper-in and noted steeplechase rider on the famed timber horse, Appolinax.

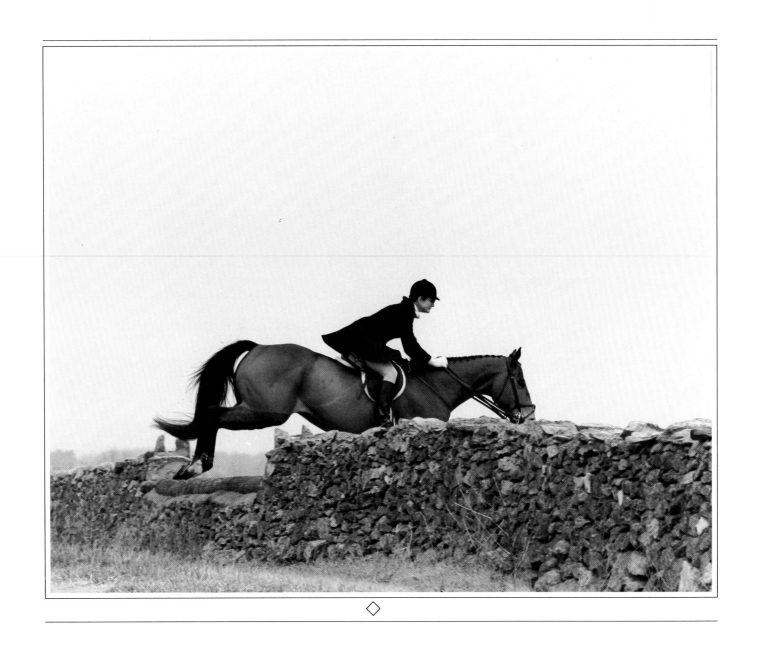

◇

*A particularly avid foxhunter, Jacqueline Onassis subscribes to
three hunts: the Essex in Peapack, New Jersey, the Piedmont in
Upperville, Virginia, and the Orange County in The Plains,
Virginia. Stone wall panels such as this, capped with a telephone
pole cemented in, are ubiquitous in Virginia.*

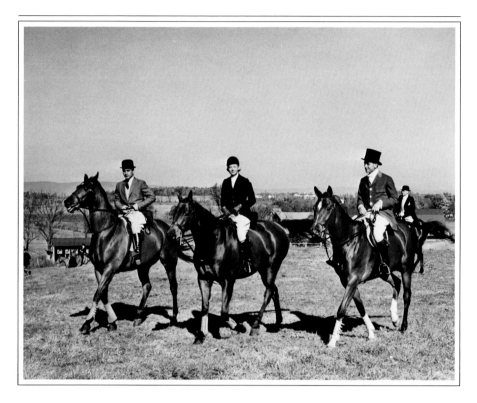

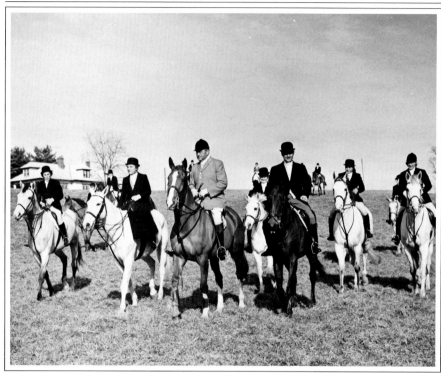

Three hunting "swells" out with the Piedmont Hunt during the 1950s (left to right) are: show rider Bobby Burke, Mrs. Winston (Ceezee) Guest, and George Clarkson. This picture shows the full range of hunting attire, from informal "ratcatcher" (Burke) to formal top hat (Clarkson).

A bevy of huntresses on white horses flank Orange County Hunt Master Morton W. "Cappy" Smith and advertising maven William Backer (in dark breeches). The ladies (left to right) are: Mrs. Barbara Woolman, Mrs. Elizabeth Furness, Mrs. June Ruhsam, Ms. Anne Foster, and Mrs. Scottie Chapman.

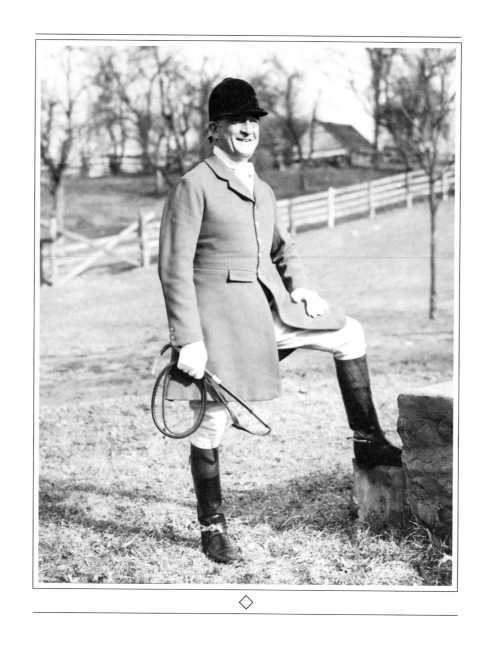

A perfectly turned-out master, William Doeller, Sr., was M.F.H. of the Old Dominion Hounds before World War II. The brown tops on his hunting boots evolved from the 18th century when boots had flaps that extended above the knee. As foxhunters began to jump over obstacles, however, the flap proved restrictive, so riders folded it below the knee, exposing the light-colored inside leather. This necessitated, moreover, the addition of now-ornamental garter straps below the knee to keep the soft boot from collapsing down the leg.

The Rappahanock Hunt (Virginia) amidst the Blue Ridge Mountains.

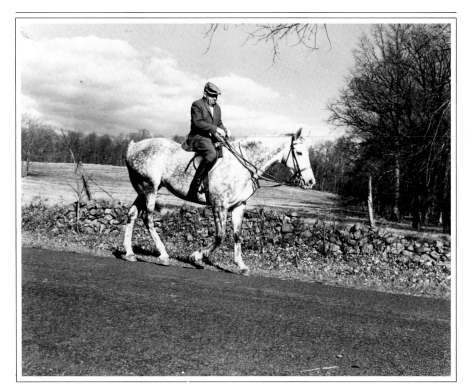

*Amos Kirk, longtime groom for Mrs. A.C. Randolph, M.F.H. of the
Piedmont Hunt.*

*The sight of a running fox never fails to quicken the pulse of hunting
enthusiasts. While there seems to be a desire to anthropomorphize
his elusive exploits, there is little argument that his adaptability
and survivability are surpassed only, perhaps, by the coyote's. His
aliases among foxhunters include Reynard, Charles, Sir Charles,
Charles James, and, oftentimes, Dammit.*

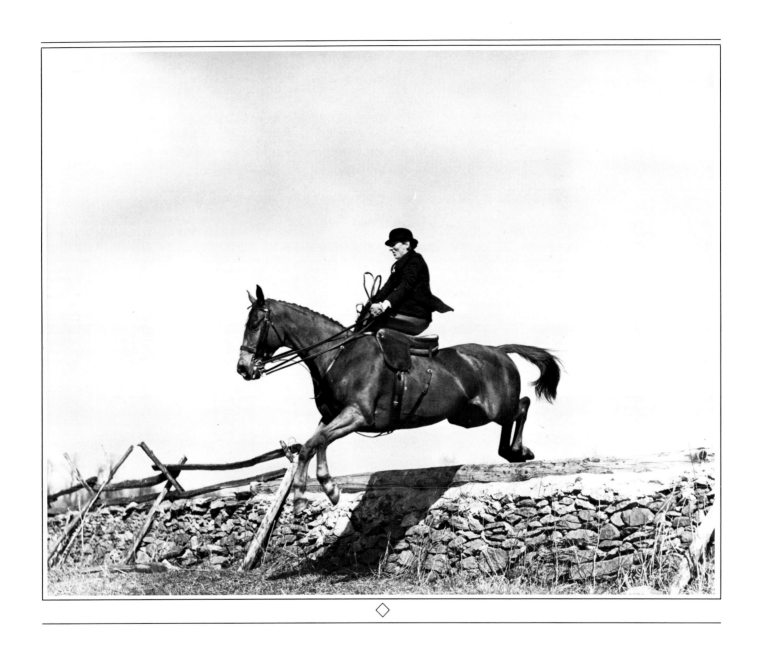

◇

At seventy-four years of age, this indomitable horsewoman, Mrs. Harriet Harper, continued to lead the "first-flighters" in the Orange County hunting field. Two remarkable aspects of this photograph: One, the layman might think, looking at her hands, that Mrs. Harper is "hanging on" by the reins. On the contrary, the horse's mouth is relaxed and the lips closed, reflecting a light touch in the rider's hands. Two, all sidesaddles position the rider's legs on the "near" or left side of the horse. Due to her malformed back, Mrs. Harper rode on the "off" side. In 1960, at the age of 75, she won a 100-mile competitive trail ride just months after breaking her hip. She competed in her last ride five years later. "A rum one to follow, and a hard one to beat!"

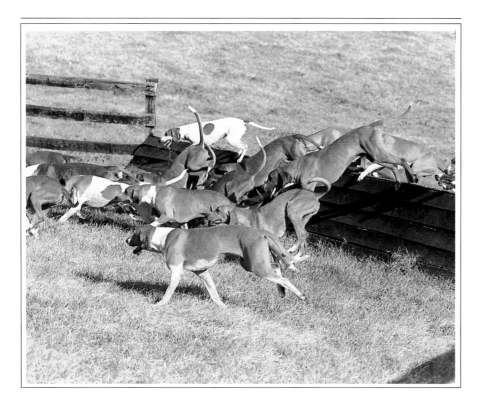

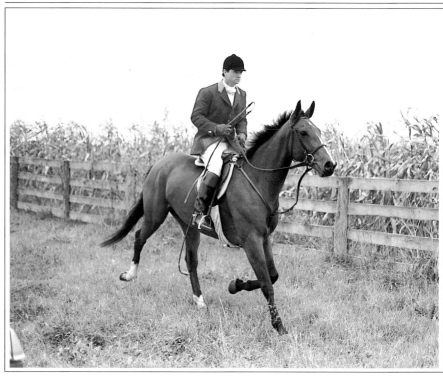

◇

◇

The Orange County Hunt hounds, 1984. One of the delights in the hunting field is the sight of hounds flowing over an obstacle while in full cry after the fox. "Full cry" refers to their urge to get forward on the line of a fox (a quality known as drive). When scenting conditions are excellent, scent is deemed to be breast high so that the hound can gallop forward with minimal dropping of his nose — a more efficient method of running.

Current Joint-Master of the Piedmont Hunt, Randy Waterman also serves as amateur whipper-in to the pack. In addition, he is an extremely successful rider and trainer of his own steeplechase horses.

◇

*Prisoners of time. Two foxhunters, unaware that the meeting time
had been changed to an hour later, ponder their predicament.
The photographer too erred and recorded perhaps his only early
appearance for a meet.*

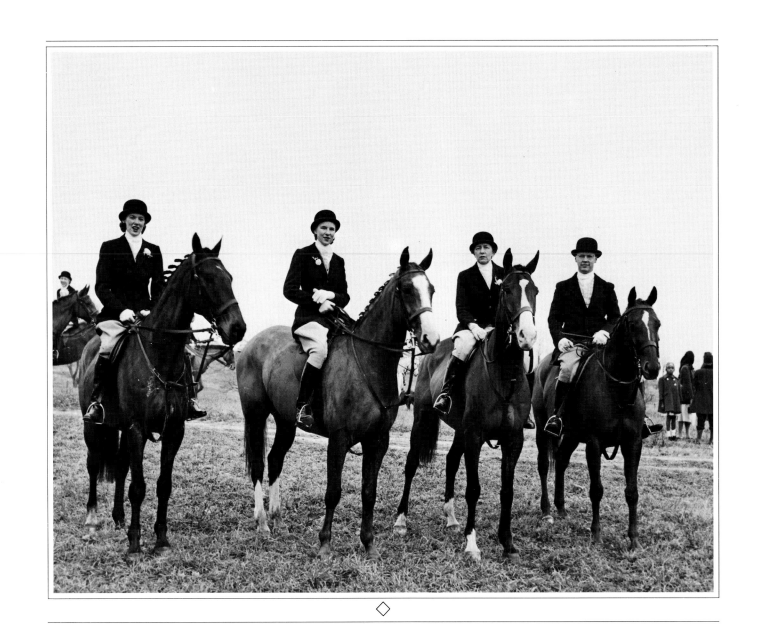

Master of the Piedmont Hunt for thirty-five years, Mrs. A.C. Randolph with her hunting family. From left, daughters Mrs. Theo Higginson, Mrs. Nina Bonney, Mrs. Randolph, and son-in-law, Thomas Higginson. A doyenne of the sporting horse world, Mrs. Randolph continues to breed and compete successful show, steeplechase, and flat racing thoroughbreds. Hunting with her Piedmont hounds is a "must" on the schedule of visiting sportsmen.

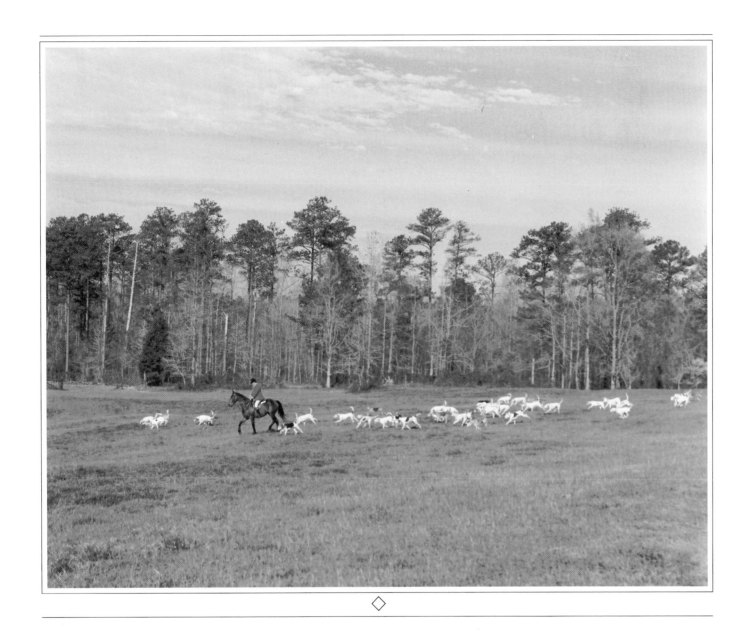

◇

*Benjamin H. Hardaway III hunts 100 of his Midland foxhounds
in the deep piney woods near Columbus, Georgia. A world-
renowned breeder of hounds, Hardaway served as president of the
Masters of Foxhounds Association from 1981 to 1984. He is also
known as a raconteur with an inexhaustible supply of pithy stories
and anecdotes.*

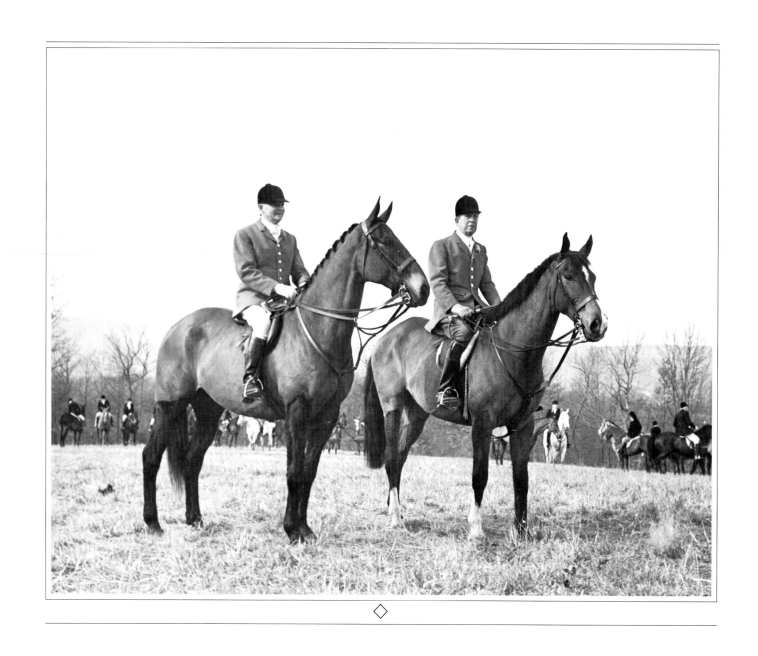

Two American foxhunting legends: on the left is Wilbur Ross Hubbard, M.F.H. of his Mr. Hubbard's Kent County Hounds. Master since 1931, Mr. Hubbard, at ninety-two, is the oldest active M.F.H. in the world. On the right is William W. Brainard, Jr., ex-M.F.H. of the Old Dominion Hounds and a world renowned judge of foxhounds, greyhounds, cattle, and horses. Brainard was president of the Virginia Foxhound club for nineteen years before poor health forced him to step down. He still serves as chairman emeritus of that organization, which he personally brought to the highest standards of repute.

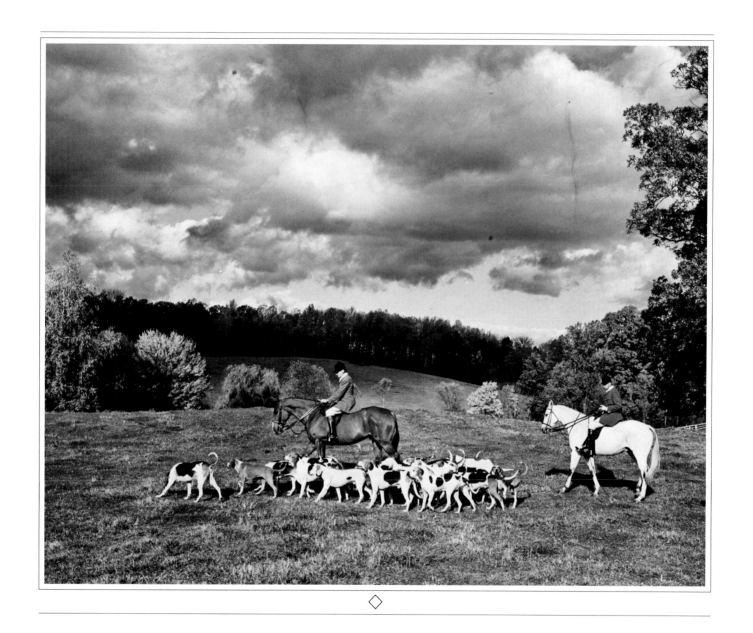

*A moody field of light intensifies this picture of Warrenton Hunt
huntsman Dick Bywaters (left) and his successor, whipper-in
Fred Duncan.*

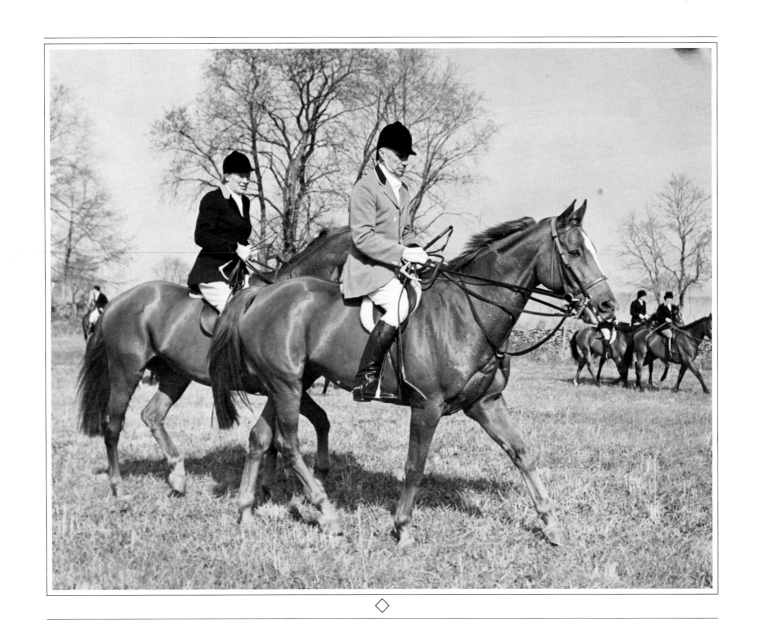

*Mr. and Mrs. Harry I. Nicholas, hunting with the Piedmont Hunt
in the mid-1970s. The late Mr. Nicholas was longtime Master of
the Pickering Hunt, and served as president of the Masters of
Foxhounds Association of America from 1975 to 1978. Nicholas
chose this photograph as his official portrait upon leaving the
presidency of the MFHA.*

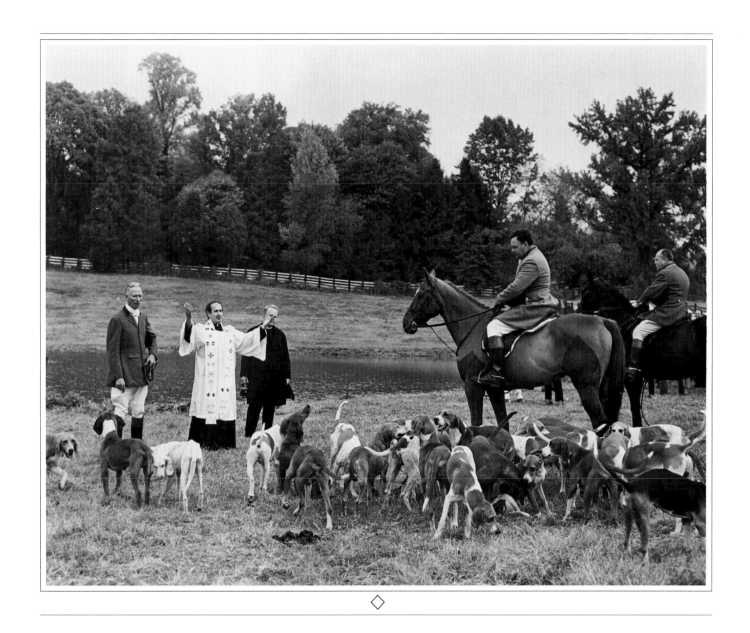

The Blessing of the Hounds of the Marlborough Hunt in the late 1960s. Joint-Master Raymond R. Ruppert is standing on the ground to the minister's right while his Joint-Master, Alfred H. Smith, Jr., is mounted on his left. An ancient English tradition also practiced by many hunts in America, the Blessing of the Hounds takes place on the opening day of formal hunting. It may be followed by a "stirrup cup" of port or sherry and then a hunt breakfast after a day's hunting.

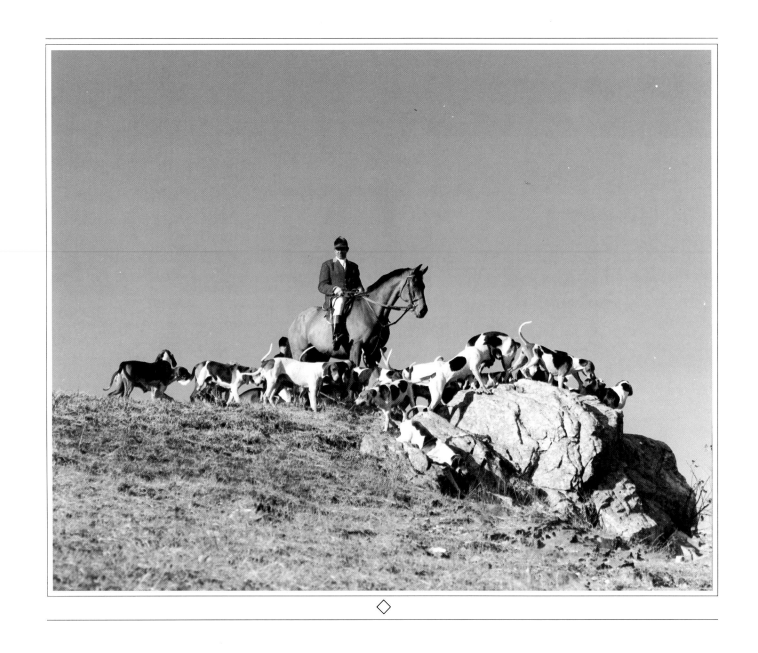

Huntsman Charlie Kirk and the Piedmont hounds check at a rocky outcropping.

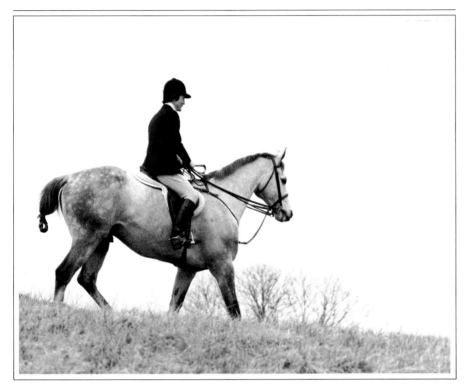

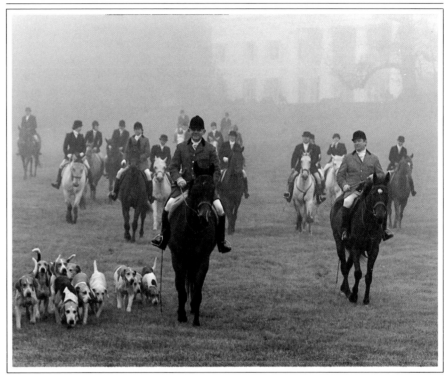

◇

Solitude is a part of hunting. The author's wife, Sally Young, backs home after hunting on her "Famous" Amos. When the ground is particularly wet or deep, many foxhunters will braid their horse's tail in a "mud tail" to keep it from getting wet and dirty, thereby irritating the horse. Thirteen-year-old Amos is a veteran of 600 miles of competitive trail rides and nine years of seven-month hunting seasons.

◇

Dr. Joseph M. Rogers, Joint-Master of the Loudoun Hunt, leads his hounds off from the Gov. Westmoreland Davis mansion of Morven Park in Leesburg, Virginia. Behind him in pink coat is his Joint-Master, Anita Graf-White, while whipper-in Harry Wight flanks him on his left. The only museum in the world devoted solely to foxhunting is housed in the right wing of the mansion.

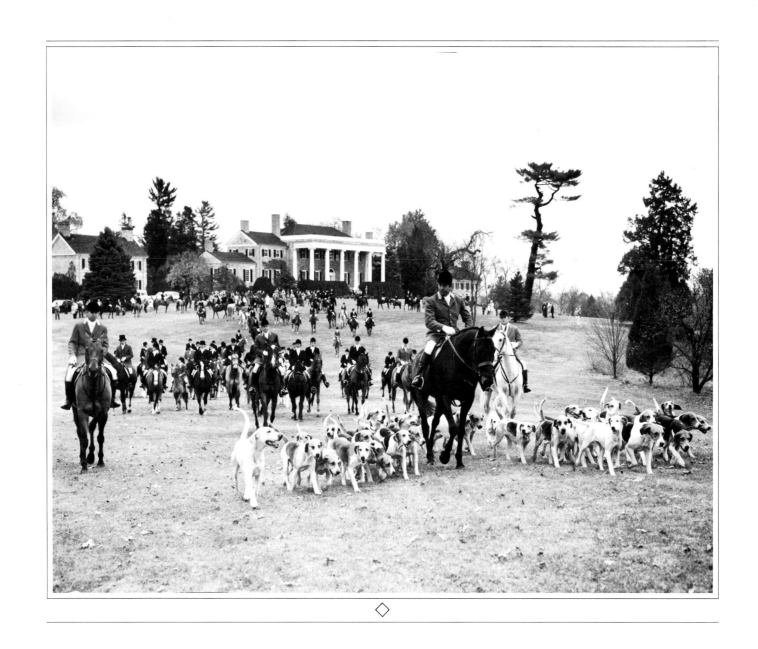

The annual opening meet of the Blue Ridge Hunt at Carter Hall
mansion has all the elements of foxhunting at its grandest: an
elegant rural setting for a field of impeccably turned-out riders,
horses, and hounds. Form is not everything with this hunt, however,
for the Blue Ridge Hunt rides as hard and as well as any hunt in
America.

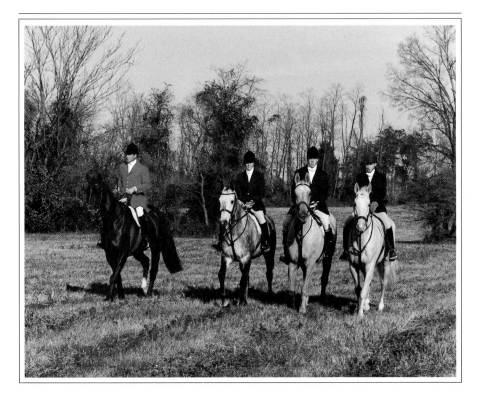

The author's family at the Thanksgiving meet in 1982.
Thanksgiving is traditionally a formal and family-oriented hunting
day and the air is redolent with the smell of mothballs as parents
rob closets to clothe their offspring in proper attire. Left to right,
the author, wife Sally, and sons Stirling and Rob.

The late Mrs. Sybilla "Billie" Greenhalgh, M.F.H. of the Blue Ridge
Hunt, c. 1960. Hawkins' superb detail is evident in this picture,
even to the point of showing what appears to be a minor skin rash
on the horse's neck and flank. A temporary ailment, it is of little
consequence to the horse.

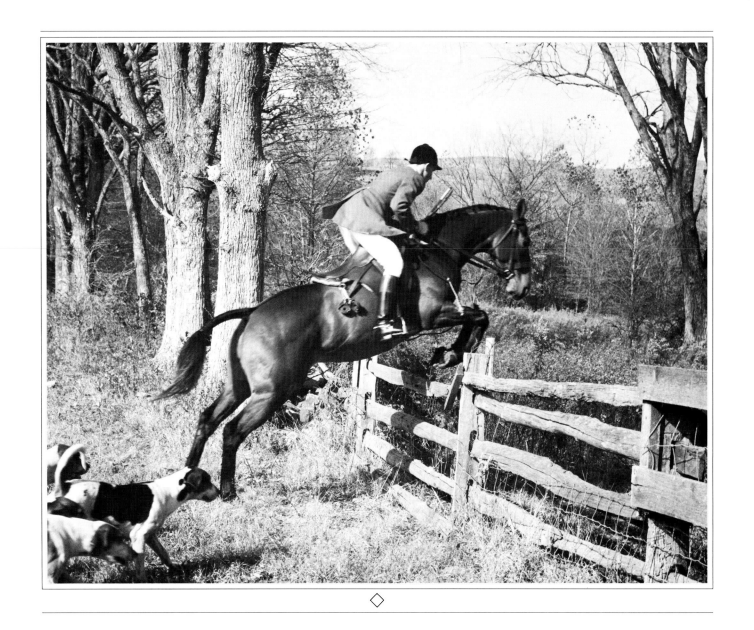

◇

*Albert Poe, then huntsman for the Piedmont Hunt, jumps a
standard post and rail fence near Upperville, Virginia. The coiled
leather straps attached to the back of his saddle are hound
couples. The couples are two-headed collars connected by a short
piece of chain and used to train young hounds. Should a youngster
tend to hunt too far from the pack, he will be "coupled" to an older,
more reliable hound until he learns that his place is with the pack.*

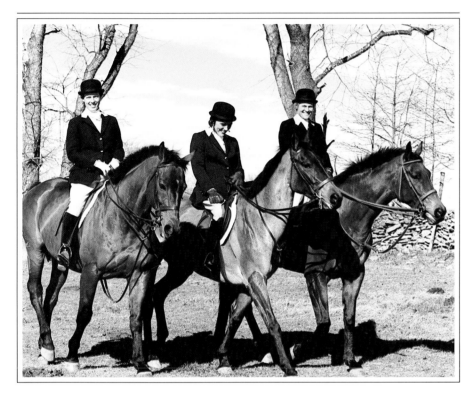

◇

◇

Like golfers who seek new courses to play, foxhunters enjoy the chance to "cap," or visit with other hunts. These three visitors to Virginia hunting are (left to right) Penny and Ann Schoellkoff and Toddy Hunter, all from the Genesee Valley Hunt in New York.

One of two professional huntsman brothers, Albert Poe now hunts the American hounds of the Middleburg Hunt, trains and rides steeplechase and flat horses, and judges hound shows.

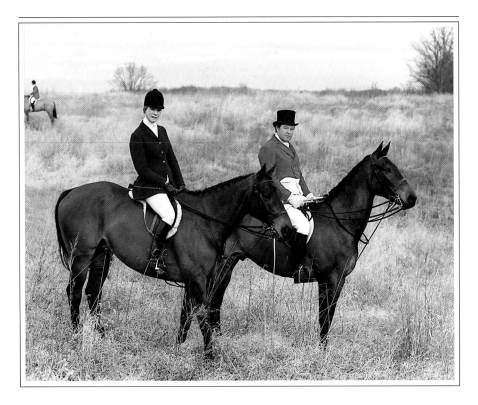

In the Piedmont Hunt field: Mr. and Mrs. William Abel-Smith. In hunting parlance, "turn-out" refers to the cleanliness and condition of one's hunting attire, horse, and tack. The Abel-Smiths are known to always be impeccably turned out.

A foxhunter who shall be nameless "becomes a cropper" or "buys some real estate," both colorful but psychologically painful euphemisms.

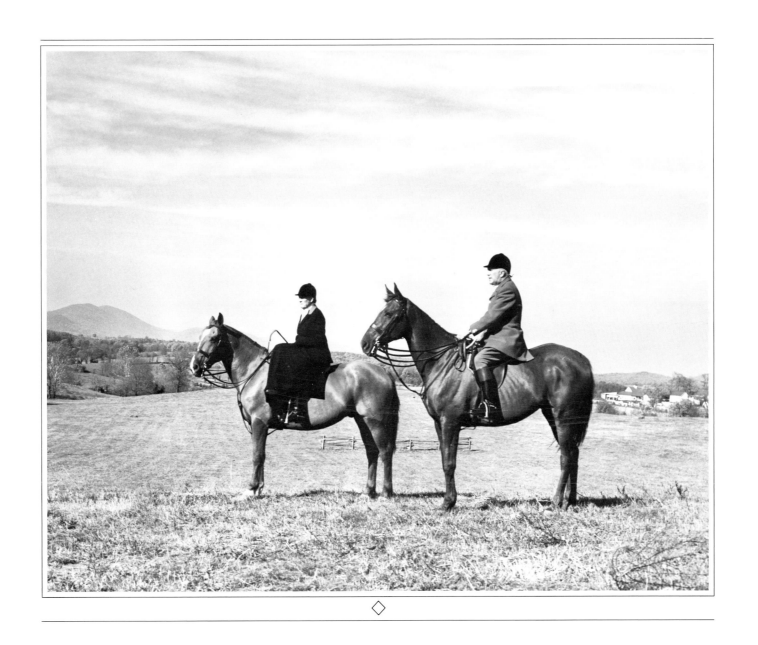

The late M.F.H. Col. Albert Hinckley and Mrs. Hinckley of the Old Dominion Hounds in the late 1960s. Mrs. Hinckley served as Field Master for the hunt during World War II, and it was her personal preference that was responsible for the unique hunting livery of pink coat with brick-colored breeches.

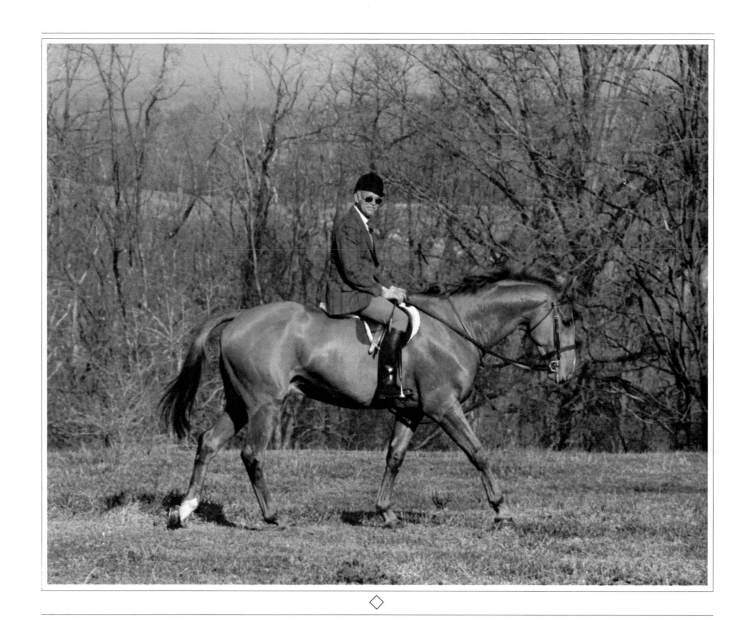

◇

Renowned foxhunting groom and racehorse trainer, Richard Hall of The Plains, Virginia, continues to hunt with the Orange County Hunt after more than fifty years. Traditionally, foxhunting grooms rode their employers' horses to the meets before the days of horse trailers, and then followed the hunts on "second horses," relief players, so to speak, for the eight-to-ten-hour hunting days. Nowadays, few can afford to employ hunting grooms, whose principal purpose is to school young horses to the hunting field.

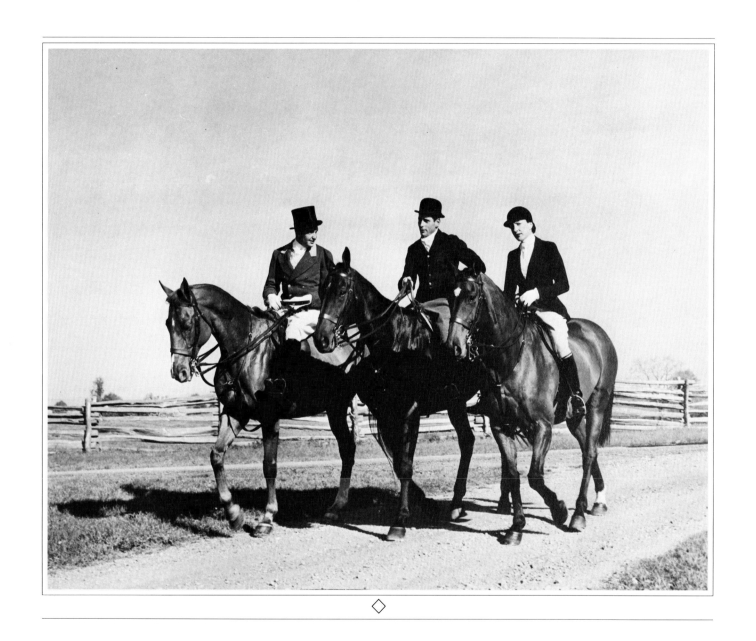

A trio of sportsmen in the Middleburg Hunt field, c. 1950. From left are: A. Ridgely White, noted steeplechase rider and trainer; D.M. "Mikey" Smithwick, Hall of Fame steeplechase rider and trainer; and Betina Belmont Ward, daughter of polo great Raymond Belmont and wife of the late Newell Ward, M.F.H. of the Middleburg Hunt. The only three appropriate hats for the hunting field are shown here: the formal top hat, worn only by men with the "shadbelly" or frock coat; the black bowler, correct for all occasions; and the velvet field cap, once worn only by professional staff, but now found everywhere.

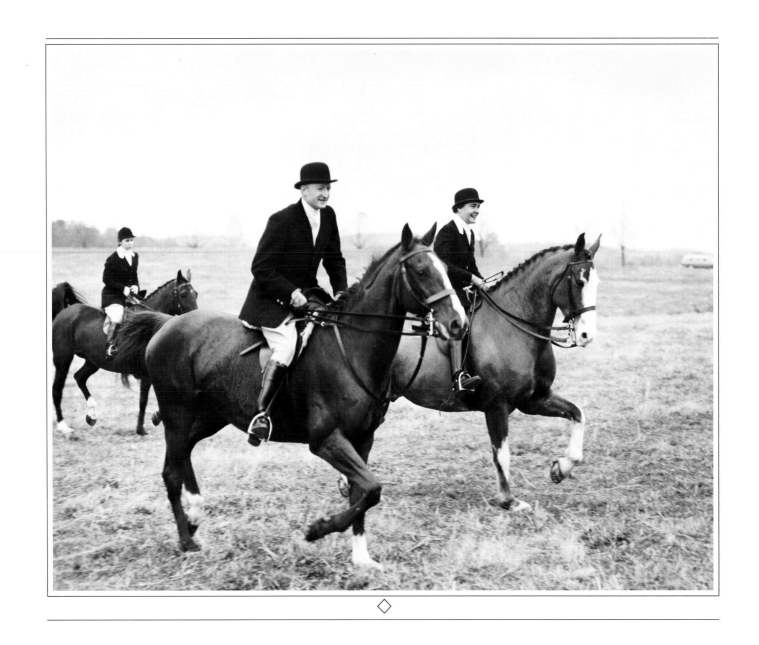

◇

Two of the most beloved personages in the Virginia foxhunting world, D. Harcourt Lees, Jr., and his wife, Scottie. Lees served as Warrenton Hunt M.F.H. from 1968 to 1981. Scottie suffered a horrendous fall in the hunting field, which left her a quadraplegic, but her cheerful good humor, so evident here, has never dimmed. She still serves as Joint-Master of the Ashland Bassets.

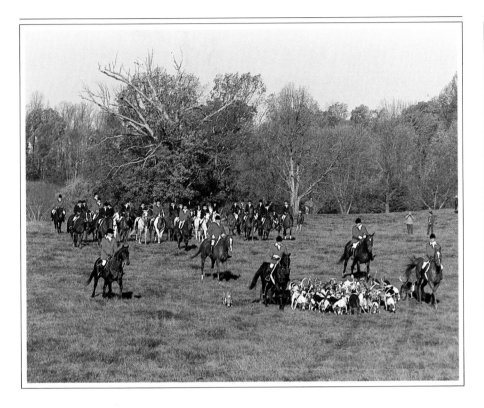

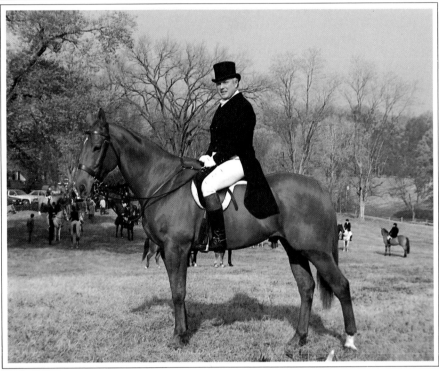

A Saturday meet of the Warrenton Hunt (1983) usually means a full field of riders. Besides the hunt staff in front, gentlemen members who have earned their "colors" may wear the distinctive pink coats, oftentimes accompanied by a top hat. Ladies, however, wear dark blue or black coats with the hunt colors on the collar.

Bruce Sundlun of the Orange County Hunt poses at his Salamander Farm before hunting in 1982. He is dressed in the most formal "shadbelly" coat and top hat. The renowned Master Eugene Reynal once described this apparel as "for rangy, hell-for-leather devils;" Sundlun refuses to dispute such an authority.

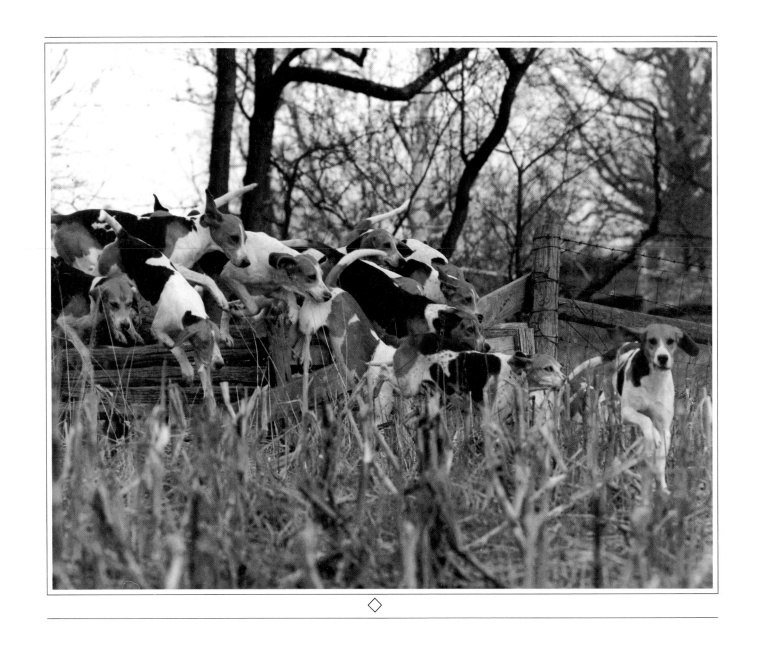

*A variety of hound portraits. What a cheerful and workmanlike
animal is the foxhound doing his job.*

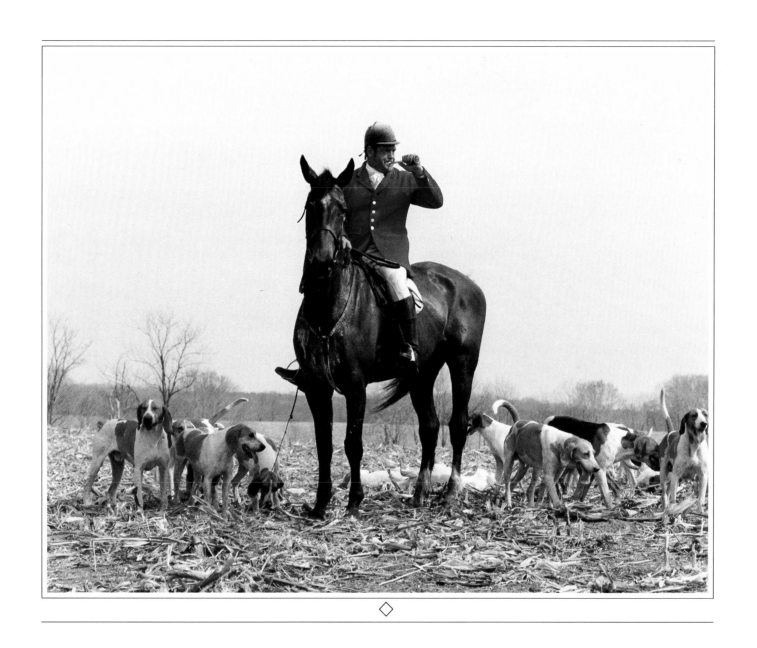

Shown before his death in 1984, Master and huntsman of the Bull Run Hunt Warren Harrover blows in his hounds after a hard chase. The foamy chest and ''tucked up'' flank of his horse attest to the rigors of the hunt. The hot and tired hounds are enjoying a rolling scratch in the cut cornfield.

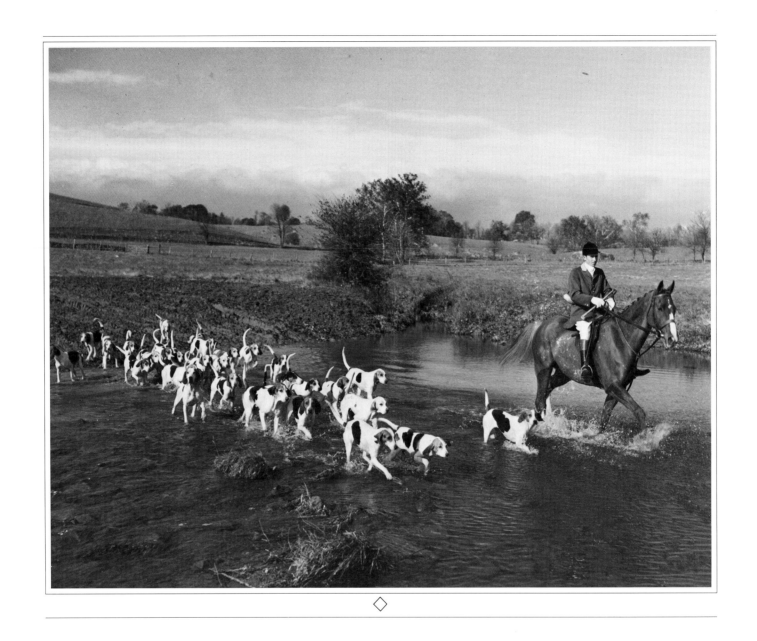

Huntsman Albert Poe and the Piedmont pack of American hounds crossing Pantherskin Creek near Upperville, Virginia. Poe is currently huntsman for the Middleburg Hunt.

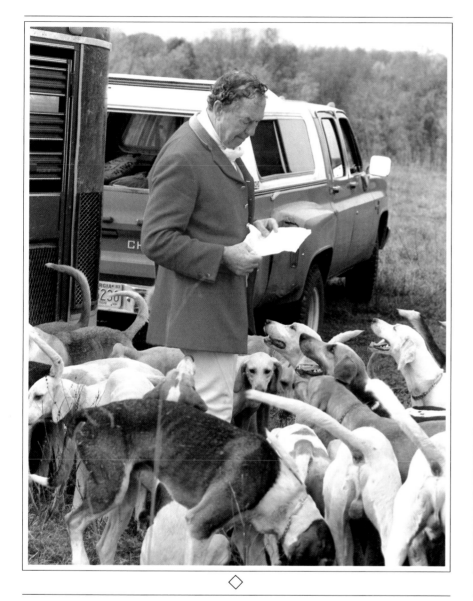

◇

◇

Calling the roll! Master Benjamin Hardaway III of Midland, Georgia, assures that all hounds have returned after a day's hunting. Ben swears that each hound answers ''Yo!'' when its name is called.

Melvin Poe, at sixty-nine years of age, is one of the most experienced huntsmen in America. His fans often say he thinks like a fox and, indeed, it is a rare day when Melvin is bested by his lifelong professional adversary.

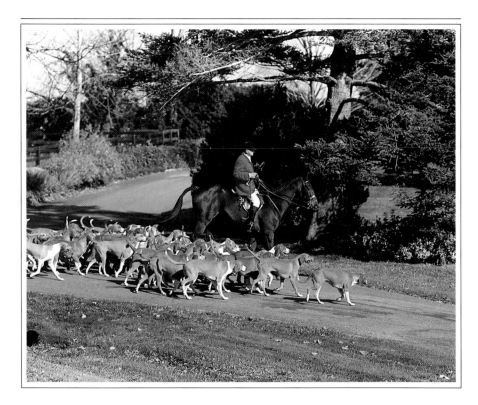

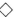

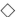

Huntsman Melvin Poe and the distinctive pack of red ring-necked hounds of the Orange County Hunt. The pistol attached to the saddle is loaded with lightweight birdshot cartridges to discipline errant hounds that may choose to chase deer or other "riot" quarry.

A fox cub at its summertime den.

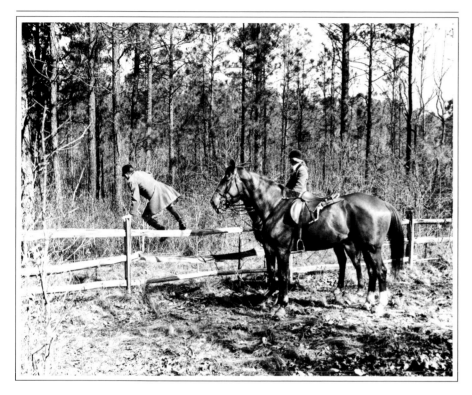

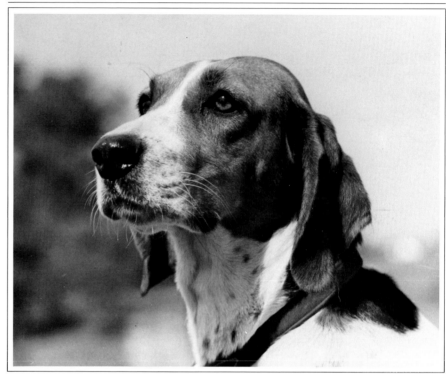

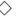

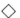

The late huntsman and Joint-Master of the Moore County Hounds, William O. ''Pappy'' Moss, heads into a swampy covert near Southern Pines, North Carolina, to get to his hounds. Holding his horse is his Joint-Master and wife, Ginnie. Mrs. Moss continues to hunt and be a driving force in the efforts to save rural land.

A noble looking animal, this foxhound exudes a quality known as ''presence.''

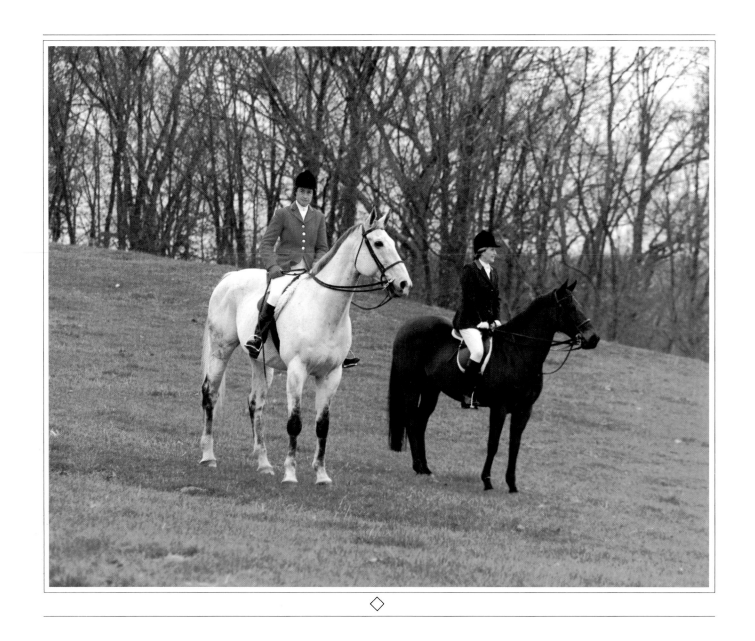

◇

*Mrs. Gary (Meg) Gardner, Joint-M.F.H. of the Middleburg Hunt,
and Mrs. Pamela Harriman, wife of the late Gov. Averell Harriman
of New York, in the hunting field. Both ladies are avid horsewomen,
often competing in horse shows, hunter trials, and pair races.*

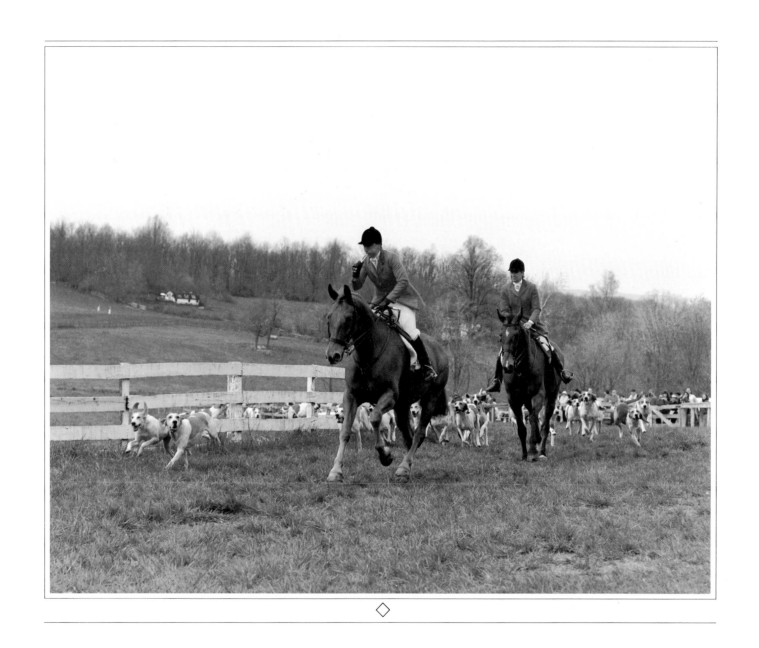

◇

*Beyond their talents in the hunt field, foxhounds are often asked
to "parade," adding color and pageantry to other sporting events.
Here, huntsman Shelley O'Higgins (left) and Master Joan Jones
parade the Bull Run hounds at a recent Middleburg steeplechase
meet.*

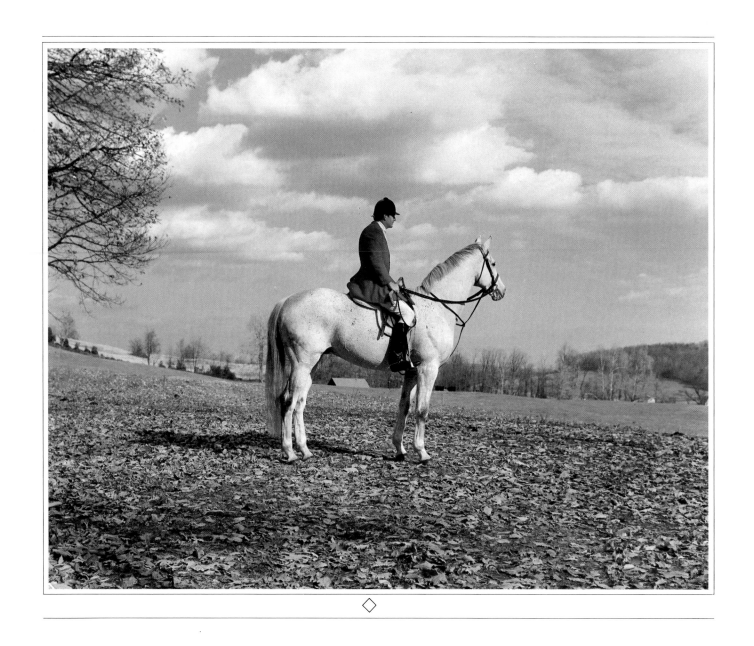

⬦

*Two of a kind: beloved Virginia steeplechase racehorse, Appolinax,
and his trainer and rider, John Coles. Two superb athletes with
gentle dispositions, both retired from racing but thoroughly at home
in the hunting field.*

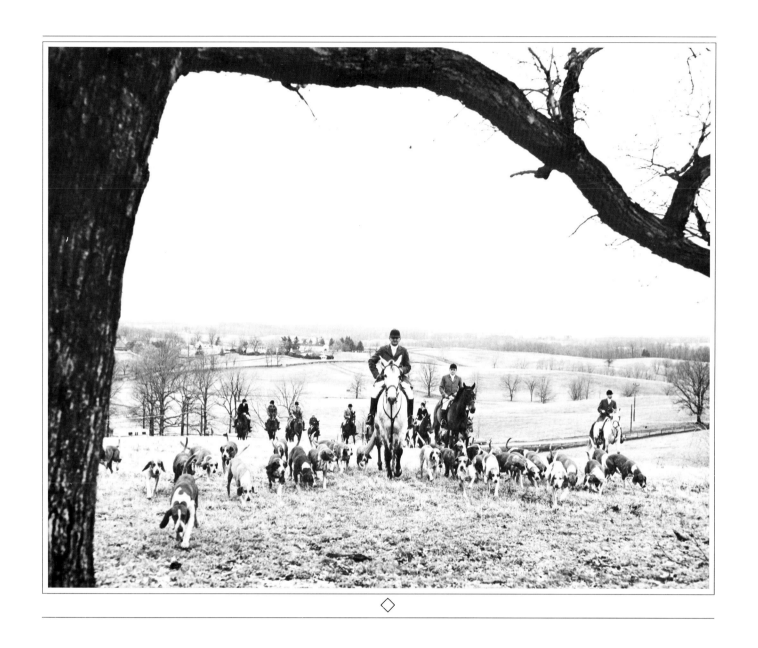

Drawing Turner's Mountain with the Orange County Hunt in the late 1960s. In the foreground (left to right) are huntsman Melvin Poe, whipper-in Morton Grimsley, and Joint-Master Henry N. Woolman III.

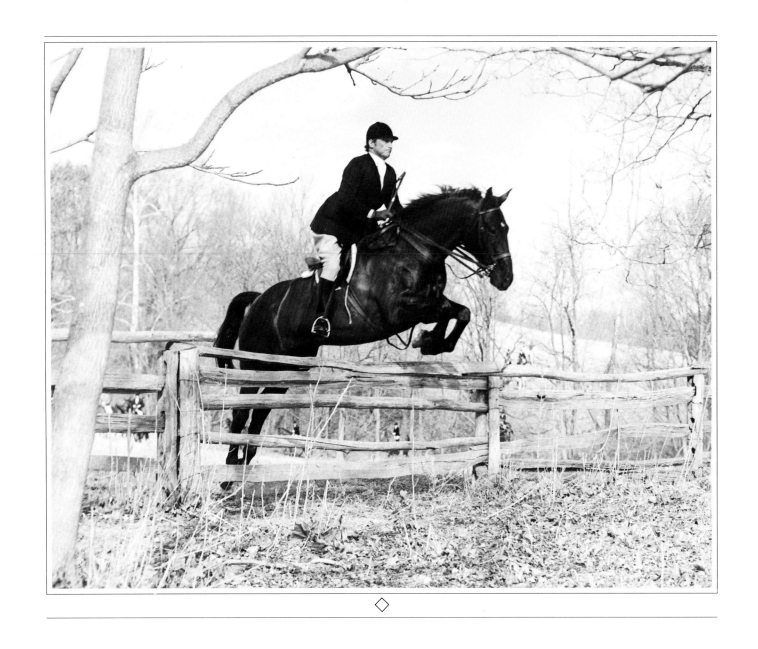

Pretty is as pretty does. Sen. John Warner and his horse Battleship show good form over a stiff fence in 1976. Like this horse, a good jumper will "tuck up" his front legs over a fence so that the forearms are parallel to the ground and the hooves don't dangle. Notice, too, how Hawkins has framed this picture using the tree limbs.

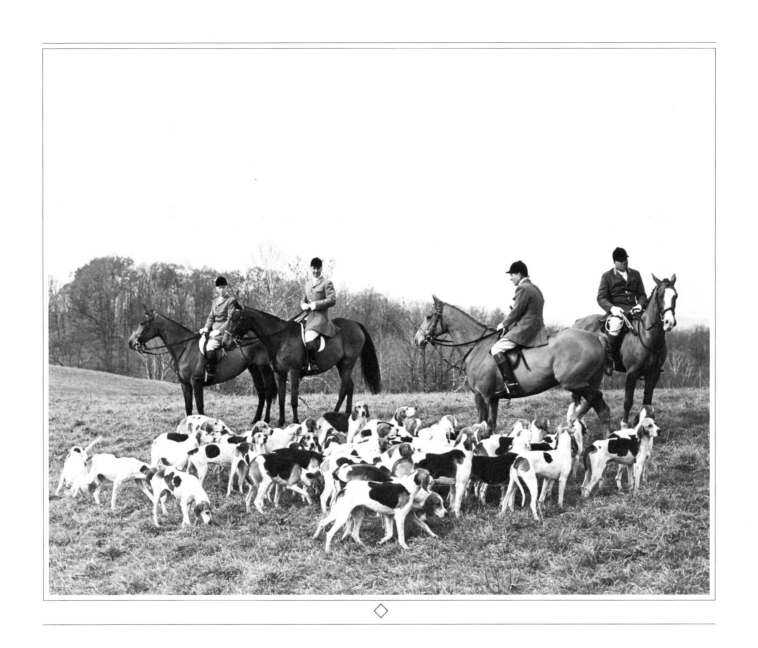

The men who provided the sport for the Middleburg Hunt in the 1970s: (left to right) Hunt President Donald Mackenzie, Master Newell J. Ward, huntsman Albert Poe, and professional whipper-in Wade Taylor.

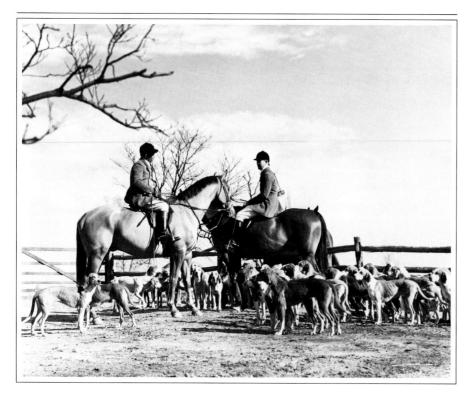

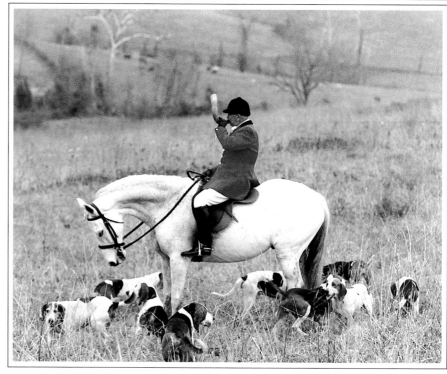

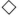

The author's father, M.F.H. Robert B. Young (left), and huntsman Kenneth Embrey with the Orange County hounds in 1952. A three-foot by four-foot enlargement of this picture adorned one wall of the famous Frost Diner in Warrenton, Virginia for fifteen years. (I still wear his pink coat and boots.)

The late Hunton Atwell was huntsman and Joint-Master of the Loudoun Hunt American pack from 1946 to 1985. Here he uses the traditional cow horn. Very few huntsmen now hunt with the cow horn, preferring the smaller, handier English copper horn. The cow horn has a deep, mournful tone, while the English "tin" horn produces a high, sharp note. One never wanted to fall on a cow horn, since it was carried suspended by a thong next to the ribs.

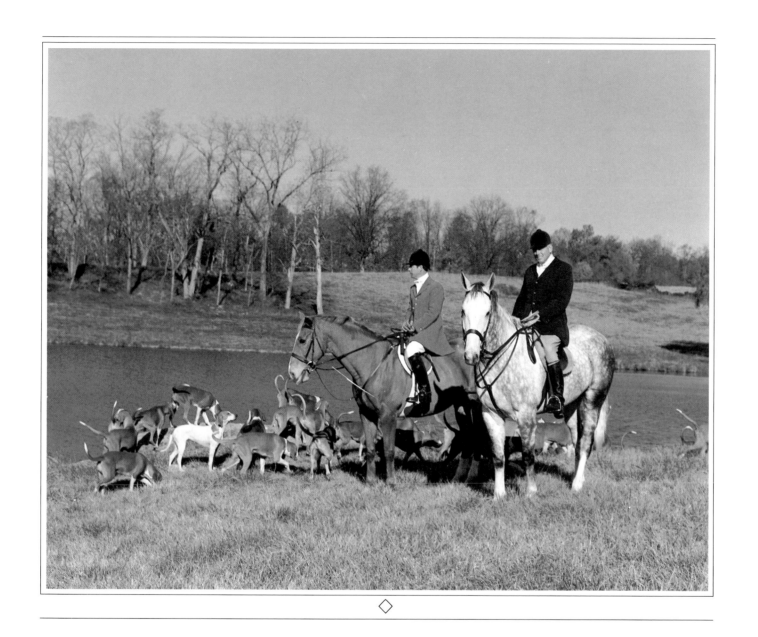

◇

*The author (left) on a rare occasion as a substitute huntsman with
the Orange County pack. My horse's personal commentary
notwithstanding (note his expression), there is always an air of
keen anticipation prior to moving off to the first draw. On the right
is OCH member, architect Charles T. Matheson.*

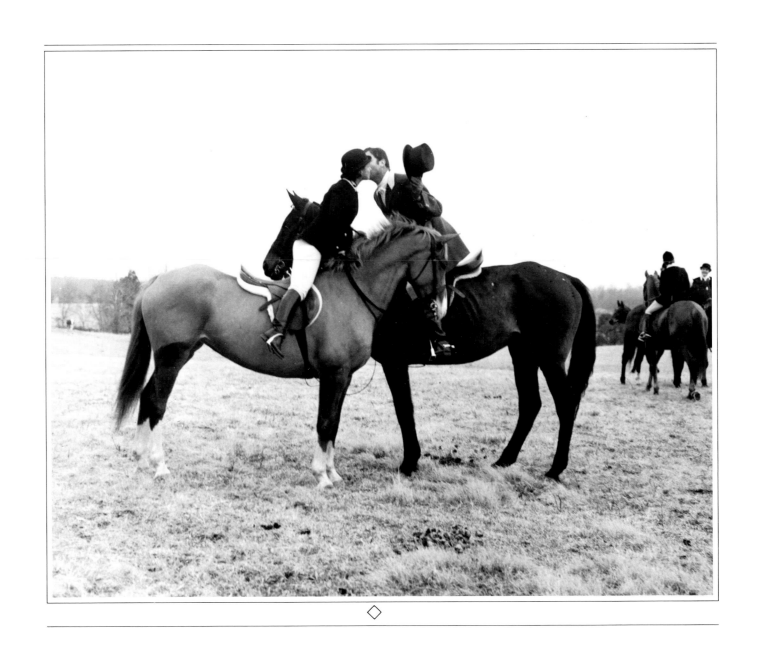

*"Covertside courtship." While such frivolousness may be viewed
askance by the foxhunting purist, at least this couple is well turned
out, and the gentleman has doffed his hat.*

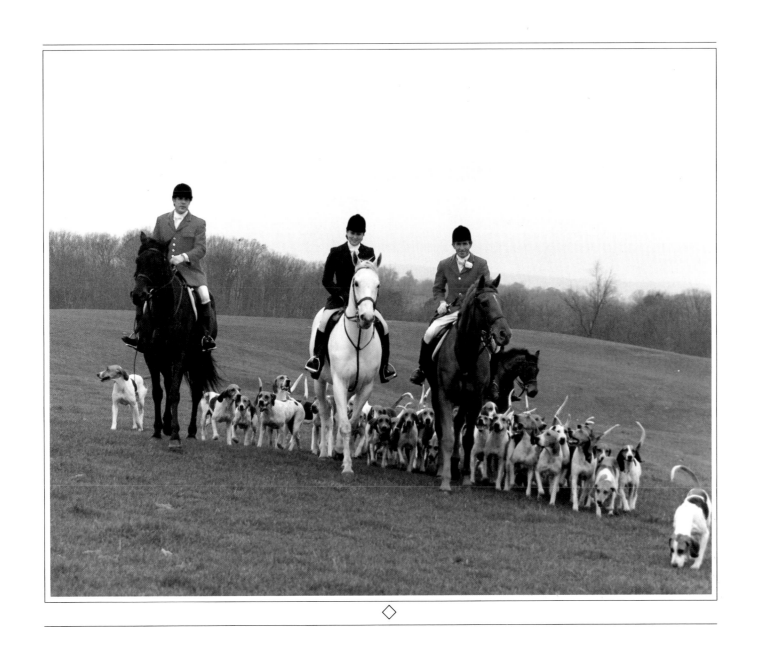

A foxhunters' wedding. Minutes after their mounted wedding
ceremony, huntsman Albert Poe (right) and his whipper-in wife,
Jackie, move the Middleburg Hunt hounds to the first draw for a
day's hunting. On the left is Joint-Master and honorary whipper-in
Dr. James Gable.

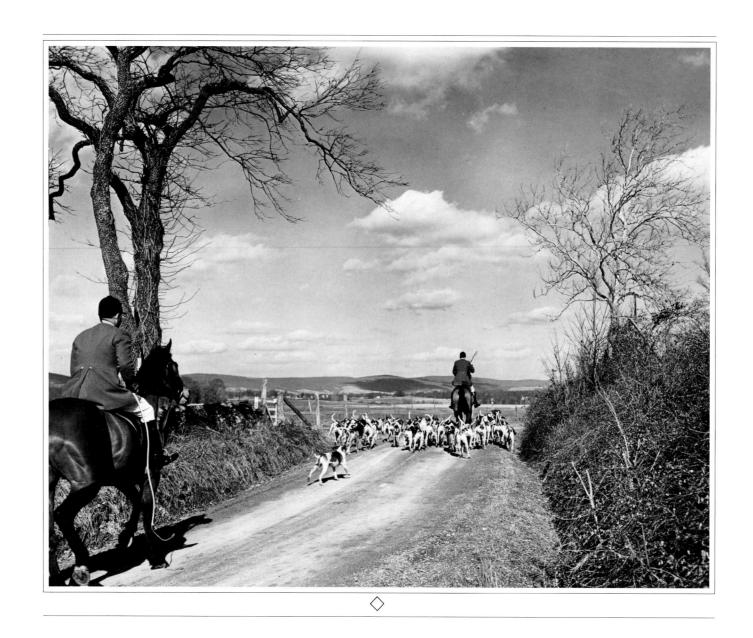

*Fourteen degrees and a surly wind rapidly drove the Piedmont
hounds to their first draw. The rider in the foreground is a
whipper-in, whose duty here is to push dawdling hounds up to the
pack. This is a perfect example of a pack well disciplined to
orderly roading behind huntsman Albert Poe.*

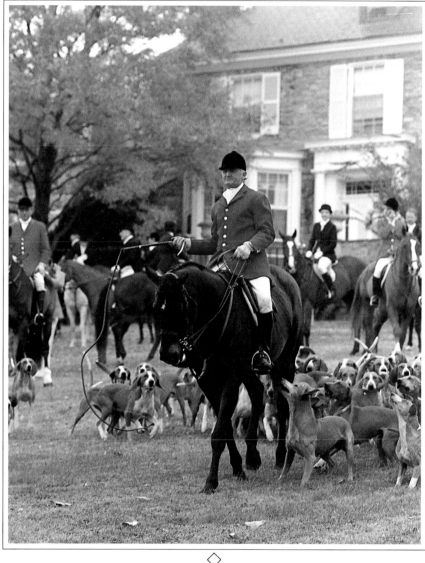

Mrs. Maximilian (Sally) Tufts, Joint-Master of the Warrenton Hunt since 1978, is an indefatigable hunter, horse trainer, and hunt organizer. She is the daughter of former Warrenton M.F.H., Baldwin Day Spilman, and step-daughter of former Warrenton M.F.H., W. Henry Pool. There seems no doubt that the most successful hunts have a tradition of involvement and leadership by generations of family members.

Dean of foxhunting huntsmen in America, Melvin Poe of the Orange County Hunt (Virginia) leaves an opening meet in the mid-1970s.

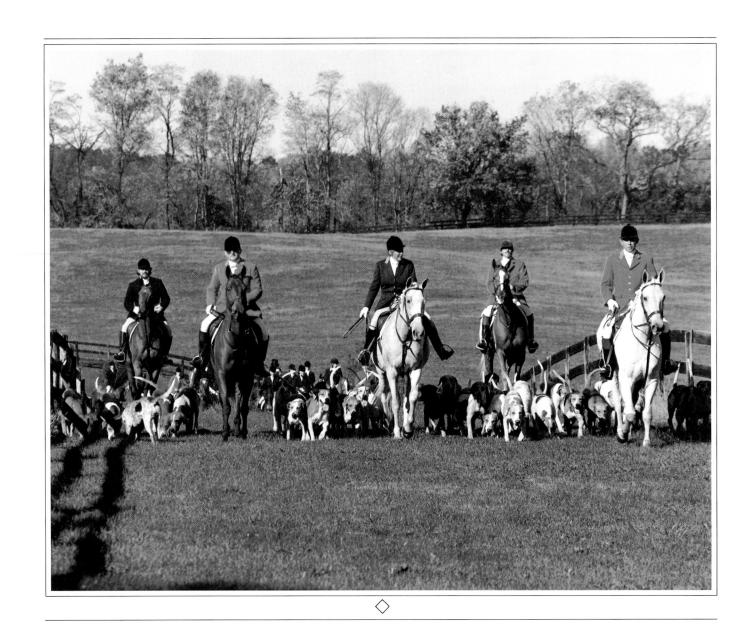

◇

*Master and staff of the Blue Ridge Hunt: (left to right) member Mark
Reed; honorary whipper-in Clifford Hunt; M.F.H. Mrs. Judy
Greenhalgh; honorary whippers-in Barry Batterton and Bobby
Pillion. Master of one of the most successful packs of English
foxhounds, both in the field and in the show ring, Mrs. Greenhalgh
sometimes hunts her hounds when she isn't whipping-in to
professional huntsman Christopher Howells.*

II

Racing

◇

The penetrating jackhammer of hooves on grassy turf beats in rhythm to the rush of air in and out of the flaring nostrils of the horses. There is the faint sound of squeaking leather and a jingle of metal as stirrups and buckles click. Occasionally the shout of a rider beside or behind you cuts through the steady din as he encourages his horse or tries to avoid being crowded into the guide wing of a jump. You are enclosed within a wall of those sounds by the force of your concentration, sensitive to every vibration of your horse's stride and each slight variation of pressure on the reins. You are on a 'chaser.

RAYMOND WOLFE, JR.,
STEEPLECHASING (NEW YORK:
THE VIKING PRESS, 1983).

*A*fter foxhunting, the equine milieu in which Hawkins has been most productive is the racing world, particularly that curiously mad and dangerous world of steeplechasing — running horses at speed over natural and manmade obstacles. As with any commercial photographer's work, there is an aesthetic and a pragmatic side that come together in Hawkins' steeplechase pictures. In order to feed the kids and dogs, one must sell pictures. Owners, riders, and trainers of racehorses, therefore, must find the picture of their expensive athletes to be accurate, clear, flattering, and dynamic. While the racing backdrop may be colorful and beautifully composed, the moment the shutter snaps on an image can be neither too soon nor too late over a fence, lest the horse appear awkward or, worse, uncoordinated. Marshall's sense of timing is uncannily adept in achieving this precision.

No lazy winner's-circle portraitist is Hawkins. He adroitly positions himself on course in order to capture horse and rider in ultimate athletic prowess. This is done at some peril, attested to by the thirteen breaks in his ribs resulting from being bowled over by an errant horse in 1979. He continues to place himself in harm's way, however, and thus, in one photo the viewer can look into the eye of the horse and fairly see its selfless drive to overcome. In another he can scan the balletic sweep of a racing field. One picture compels us to lift our foot in an instinctive attempt to aid a horse dragging its hind legs over a jump, another allows leisurely viewing of the steeplechase scene against its rural backdrop. Whatever the level of intensity, each Hawkins photograph is a facet to be studied and admired in the glittering gem of horse racing.

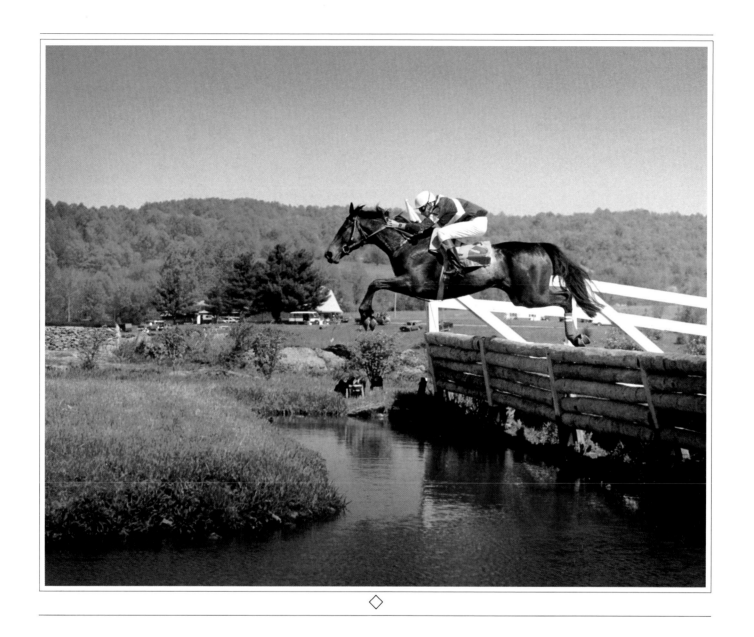

◇

An explosive phenomenon on the steeplechase scene in the spring of 1988, Von Csadek is shown flying the timber water jump in the sixty-third running of the Virginia Gold Cup at Great Meadow race course. An undistinguished hurdler in his earlier career, Von Csadek capped decisive timber victories at Richmond and Middleburg by besting a field of seasoned racers by a full twenty-five seconds. Even more amazing is the fact that his rider, Patrick Worrall, was only sixteen years old at the time.

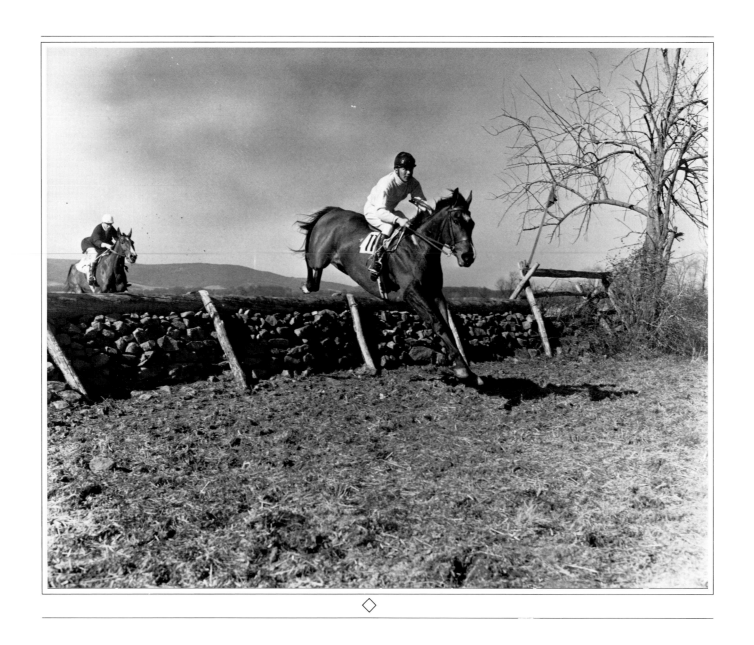

On their way to Maryland Hunt Cup and Grand National victories,
Tommy Smith and Jay Trump stopped off to win the Piedmont Plate
in 1962 over the post and rails, stone walls, and plank-board fences
of the Piedmont Point to Point in Upperville, Virginia.

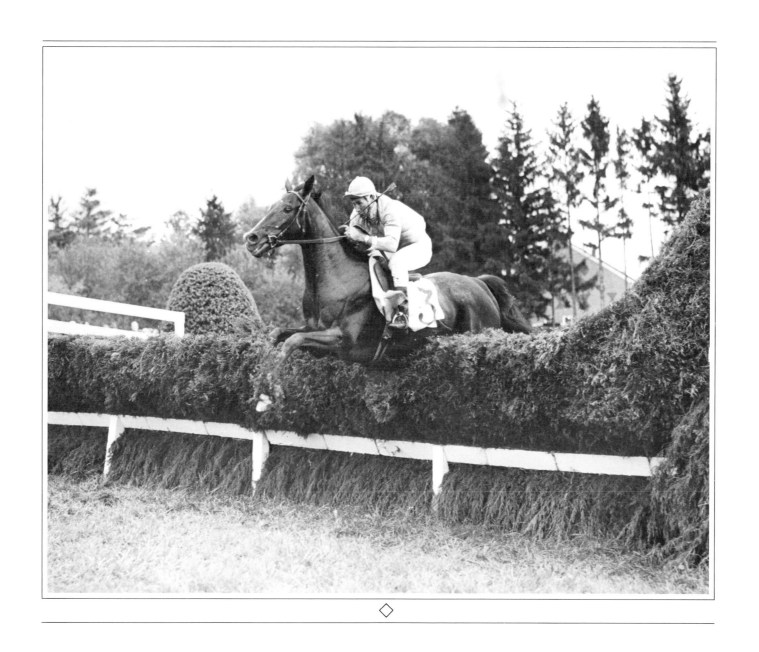

*Joe Aitcheson and his mount graphically demonstrate the principal
characteristic of a natural hedge fence at the Rolling Rock Races
in Ligonier, Pennsylvania. Carefully manicured, this living hurdle,
was "trained" to present a solid-looking, yet flexible obstacle so
that horses could "brush through" it as Aitcheson's horse is doing.
Novice or poorly trained jumpers might leap over it, losing
valuable time.*

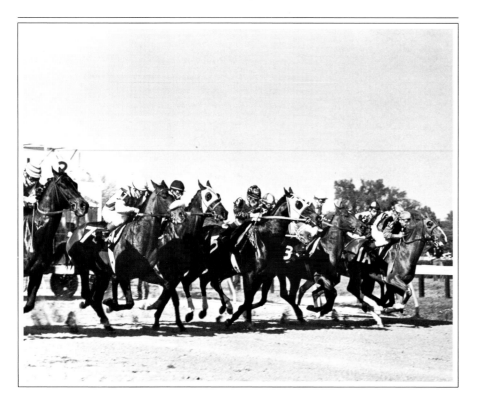

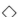

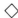

A start on the flat at Pimlico race course in Maryland. A good start is critical for establishing position, frame of mind, and a quick settling into the rider's race plan. A poor start can render a horse rattled, startled, despondent, or eating dirt. One can usually tell from each horse's body language which got away well and which didn't.

Paddock serenity under the oaks and maples of the Glenwood course outside Middleburg, Virginia in 1972. A cradle of steeplechasing in Virginia, the Glenwood couse offers spectators boxes and bleachers carved from the native rock outcropping and an unsurpassed vista of the rolling one-mile course. Three yearly race meetings along with horse, pony, and dog shows are a sampling of the rural sporting events made possible through the generous bequest of the land to a trust by the late Daniel C. Sands, longtime M.F.H. of the Middleburg Hunt.

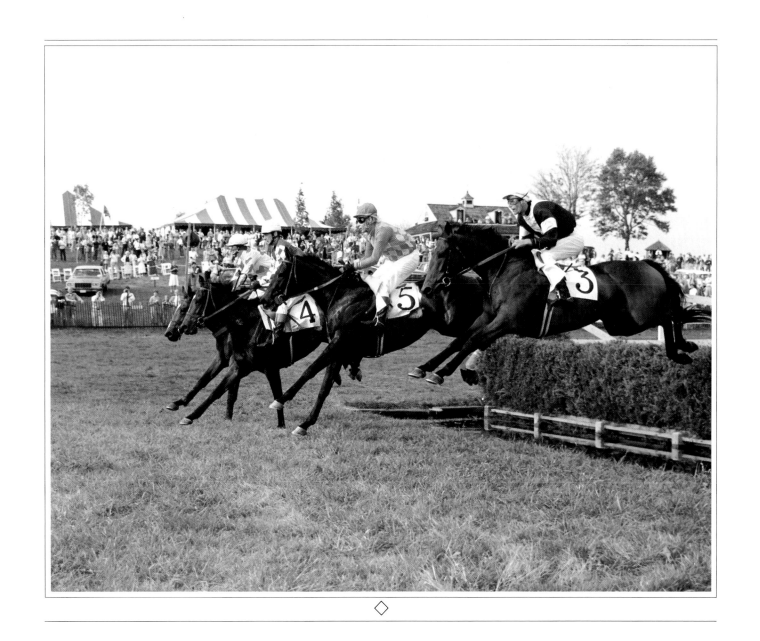

Over the water jump at Great Meadow race course outside The Plains, Virginia, this quartet provides a balletic study of hurdle jumping. From left to right are Joy Slater Carrier in pink cap on Mrs. Miles Valentine's Val de la Meuse (the eventual winner); Bertram Firestone's Statesmanship (#4); Herman Playforth, aboard his Romanair (#5); and D.M. "Speedy" Smithwick, Jr., piloting Mrs. Michael Sanger's Uncle Edwin.

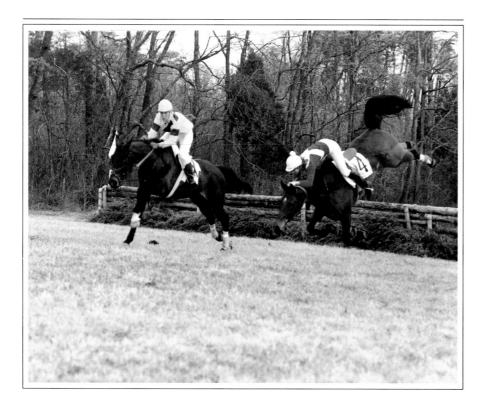
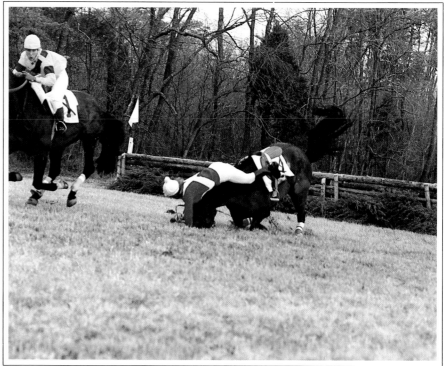

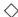

The anatomy of a steeplechase fall. The cast of characters are not important; both seem to know how to minimize a disastrous situation, and no one was hurt.

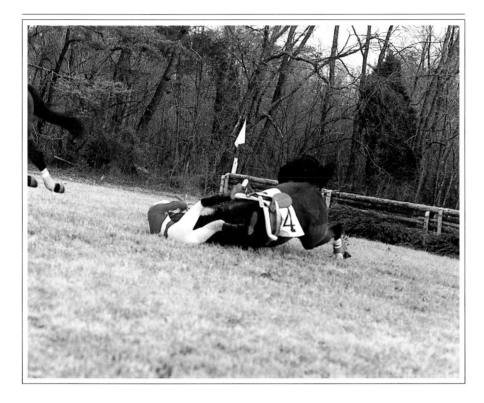

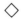

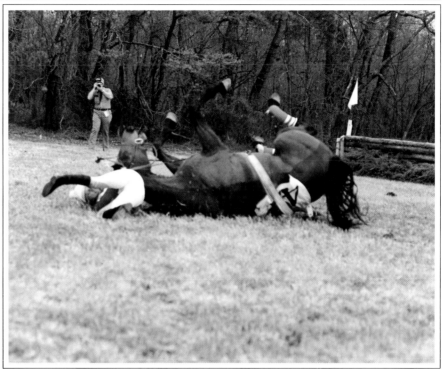

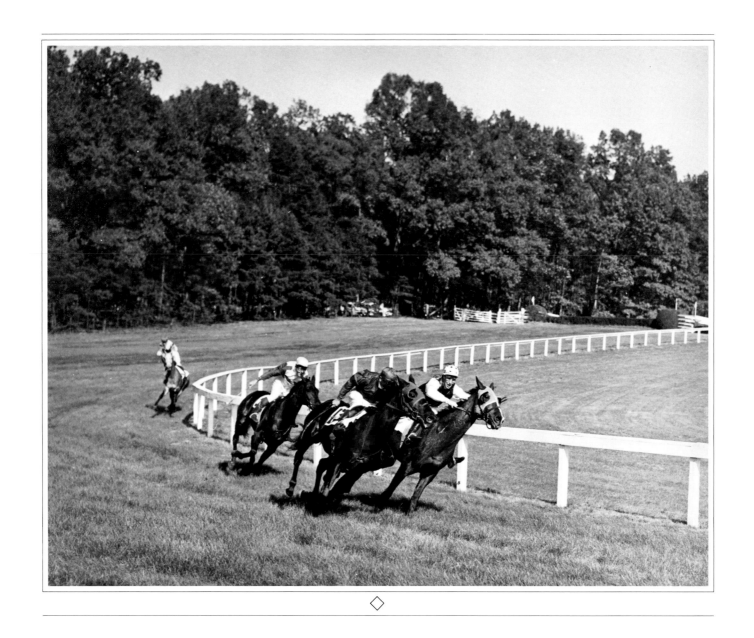

◇

The final turn on the flat at the Montpelier Races in Orange, Virginia. The fluid sweep of the inside rail accentuates the bend of the horses and riders against the centrifugal force of the turn. Suddenly our eye is arrested by the contrasting lines of motion created by the trailing pair, perhaps about to part company.

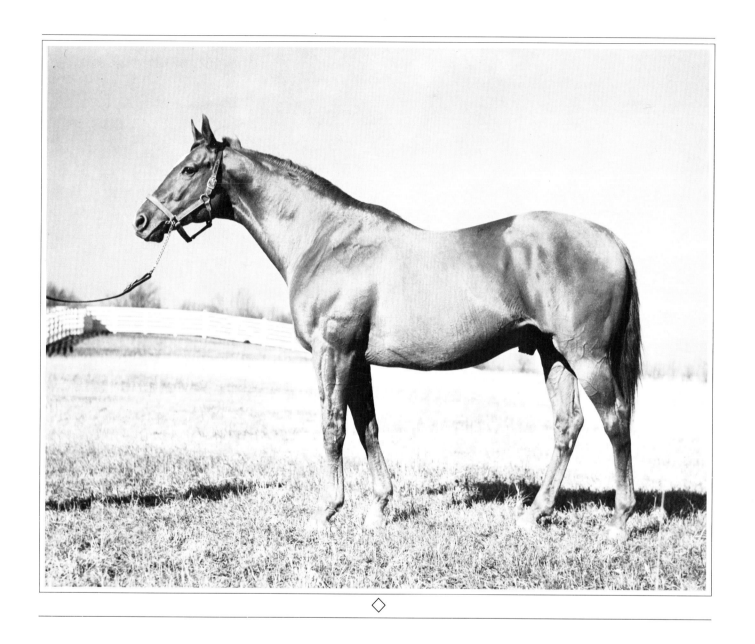

Head Play, 1948. Hawkins did this portrait while the horse was standing at stud at North Wales Farm in Virginia. Head Play finished second in the 1933 Kentucky Derby. This is a perfect example of Hawkins' talent as a portraitist. There are absolutely no distractions from the horse as the focal point. He is standing free, with the handler out of the camera's field; there is nothing to distract the eye; and the horse's position with relation to the light source is such that it flatters the musculature, minimizes obscuring shadows, and exposes all four limbs for careful scrutiny. Consider for a moment the difficulties of coaxing a sensitive and high-strung thoroughbred to hold this pose.

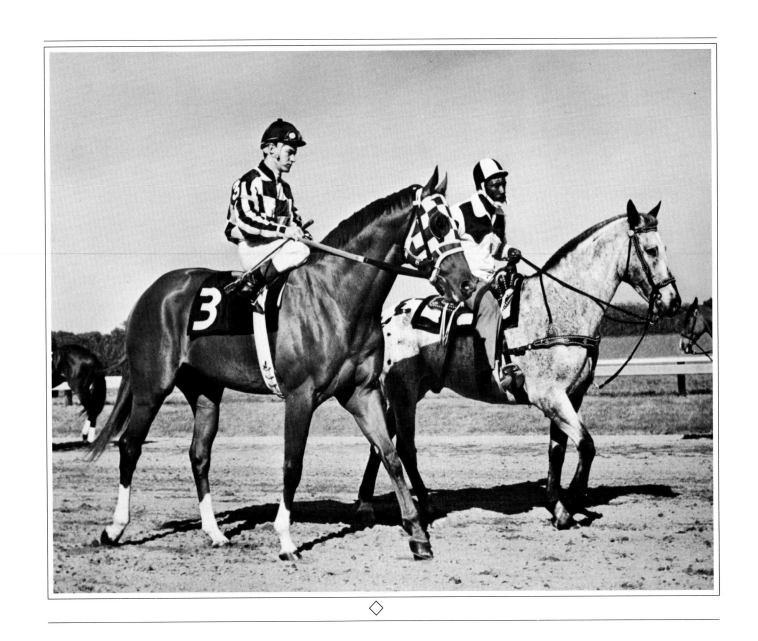

◇

Perhaps one of Hawkins' most successful commercial pictures is
this one of Secretariat being led to the post before winning the
second leg of his 1973 Triple Crown triumph. Marshall has other
pictures of Secretariat in singular, portrait-like stances, but this
picture contains certain realities that Marshall prefers: the quiet
confidence exuded by jockey Ron Turcotte and his partner; the
almost insolent nonchalance of the outrider; the disembodied
portions of other horses in the background; and the contrast
between the colors of the two central horses. All of these factors
enhance the stately presence of "Big Red," perhaps the most beloved
racehorse of the modern era.

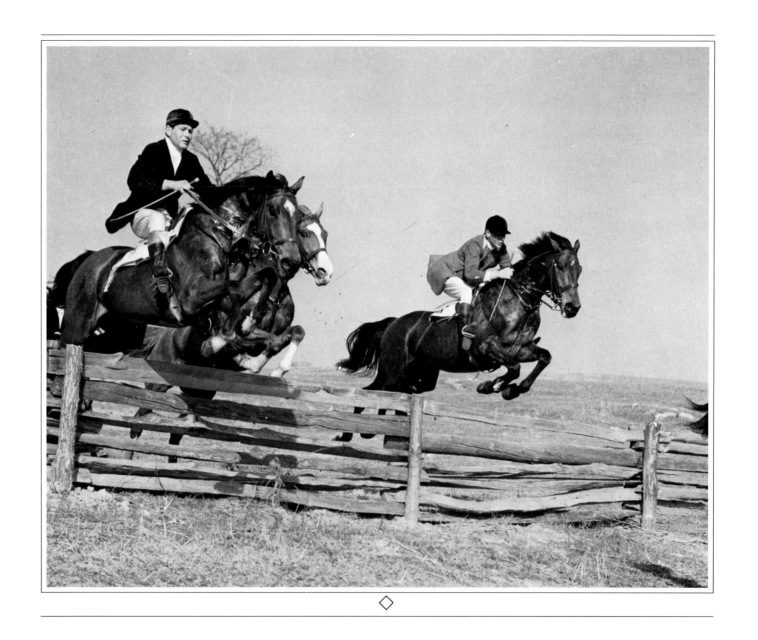

◇

The Smithwick brothers in competition always provided thrilling racing moments from the '40s well into the '60s. Paddy is on the left in the black coat and Mikey to the right. The only brother combination inducted into racing's Hall of Fame, they have left an indelible imprint on American steeplechasing. Mikey continues the family tradition, and is one of the all-time leading trainers of steeplechase horses.

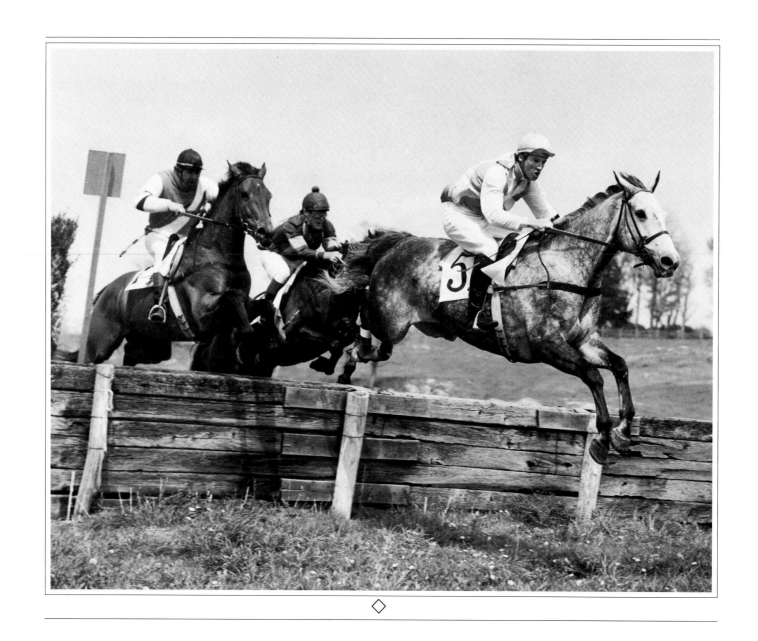

*Tight over timber! Three veteran timber riders and owners vie for
the lead in a 1980s race at Blue Ridge Point to Point. (left to right)
"Tennessee" Roy Graham, Charles "Chick" Owens, and Randy
Waterman. All three of these men are amateur sportsmen.*

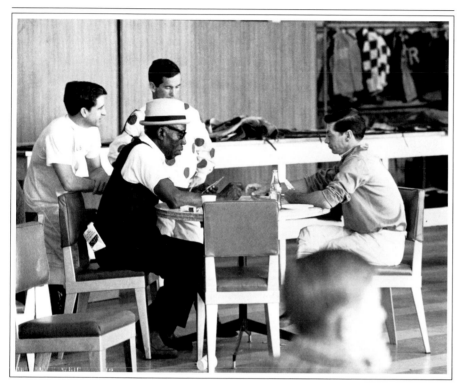

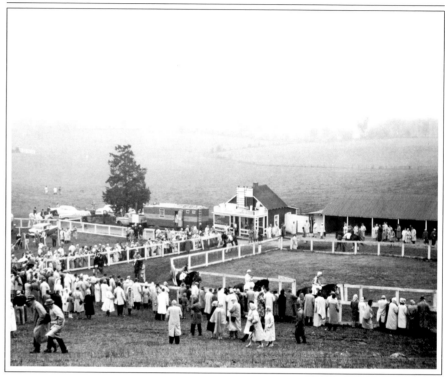

*Veteran jockeys Don Brumfield (in white T-shirt) and Bill
Shoemaker (in polka-dot silks) watch Bill ("Don't call me Willie")
Hartack play cards with a valet in the Pimlico jockeys' room
between races.*

*The paddock at the Broadview, Virginia course during the 1940s.
In the left background one can discern the chalkboard tripods of
the traveling steeplechase bookmakers. Although gambling was
illegal in Virginia, "Golden," Davy Jones and their compatriots
operated through benign neglect by the local and state authorities.
Proof that there was, indeed, honor among thieves (their odds
were so outrageously low as to be criminal), these bookies never
welched on a bet and became as revered and renowned as the horses
they touted. Zealous prosecutors effected their extinction in the late
1970s, and the steeplechase scene lost some of its most vibrant color.*

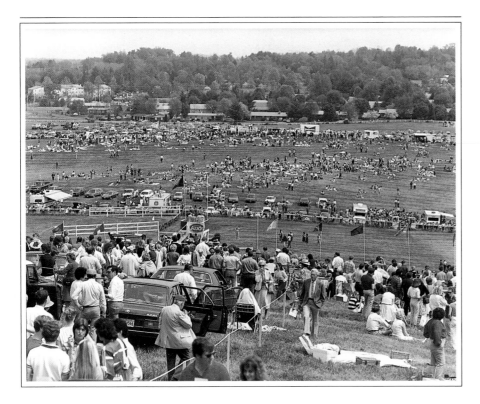

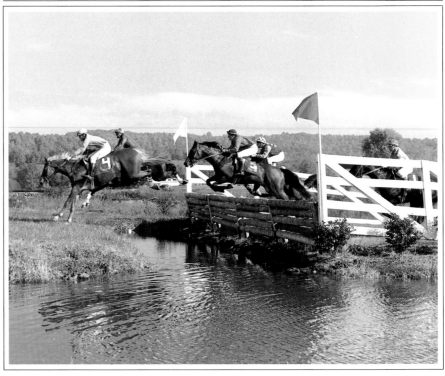

◇

◇

The Virginia Gold Cup scene as remembered by generations of racegoers who camped out ''on the hill'' at the old Broadview course. Encroaching development, visible in the background, forced moving the race meet to the Great Meadow course outside of The Plains. The sweeping, hilly one-mile circuit created the Virginia timber horse that could grind out four turns over twenty-four stacked rail fences, and provided steeplechase lovers with some of the most thrilling racing to be found anywhere.

The water jump at the Great Meadow timber course in The Plains, Virginia is a photographer's mecca. Since horses at gallop will easily cover twenty-five feet in a leap over an obstacle, and since they cannot see the water portion of the jump before takeoff, the water plays little part unless the horse makes a mistake on approach. Regardless of the racing realities, the water jump is a scenic crowd pleaser.

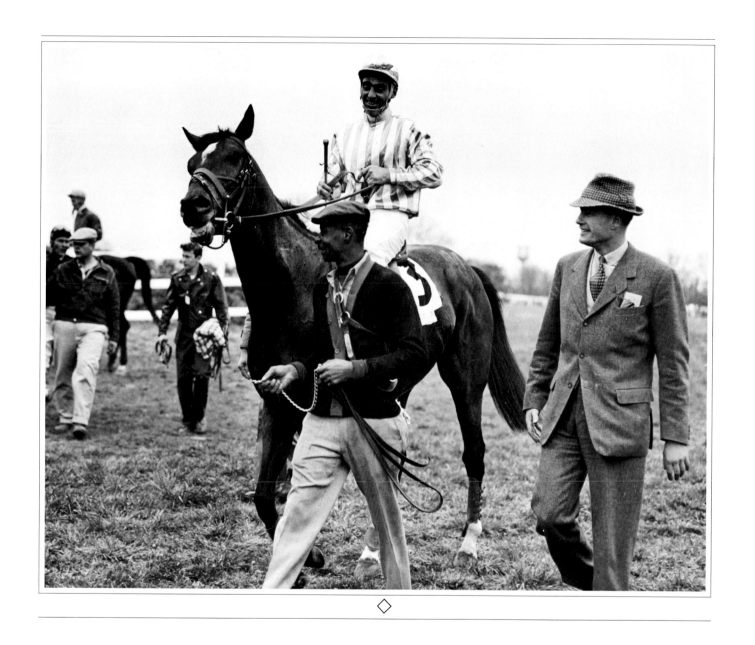

George L. Ohrstrom (right) heads for the winner's circle at the Deep Run Hunt Cup in 1958. Aboard Ohrstrom's Frenchbred 'chaser, Fast, is Danny Marzani. Leading Fast is former race rider Buck Bland, who has been an Ohrstrom horseman all his life and who continues to oversee Ohrstrom's Whitewood stables even into retirement.

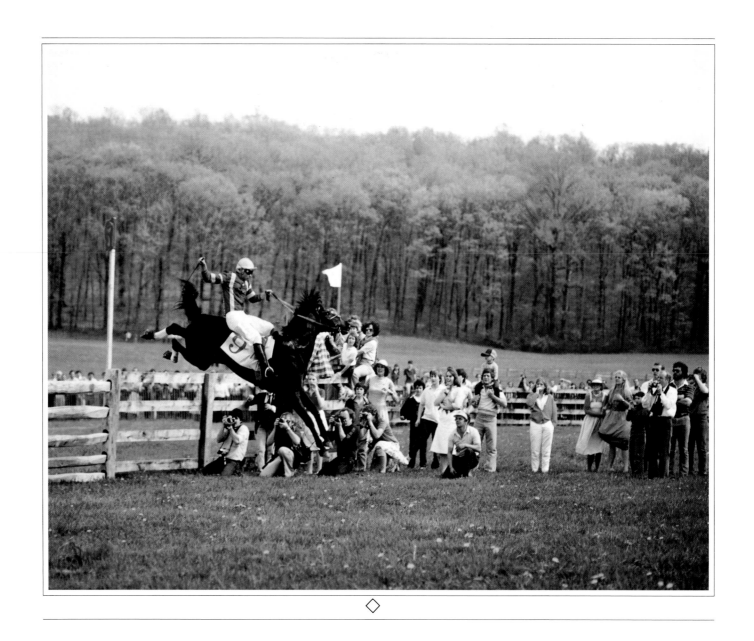

A rough descent over the infamous third fence at the Maryland Hunt Cup, which is run over Worthington Farms' four-mile course. This straight up 5 foot 2 inch post and rail fence is unforgiving except for the best of jumpers. The fate of this unidentified duo is unknown.

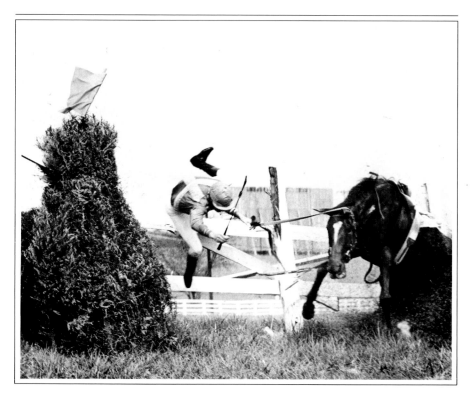

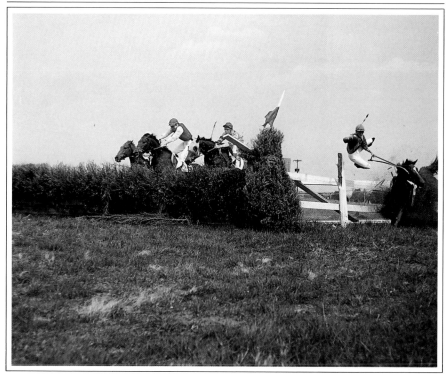

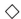

*A dramatic example of the explosive danger confronting every
steeplechase rider. Jockey "Popeye" Hatcher had difficulties steering
his independent-minded mount throughout this race with this
disastrous result. Fortunately, fence guide wings are designed to
break away and neither horse nor Hatcher were seriously hurt.
Hawkins took both pictures simultaneously with two cameras
secured to a hand-held mount, each activated by remote cables.*

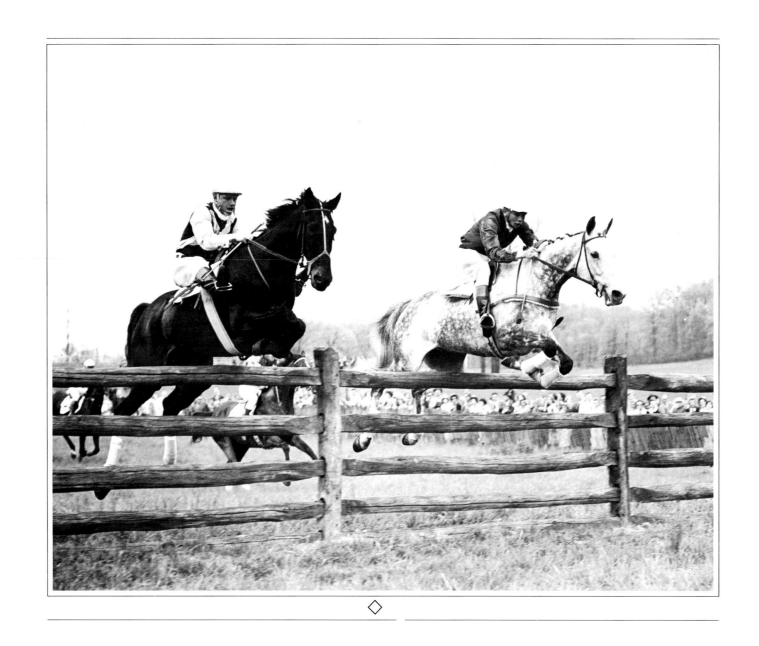

"The Hunt Cup" means only one race — The Maryland Hunt Cup timber race held the last Saturday in April each year in Glyndon, Maryland. For ninety-five years, this legendary and solitary race has attracted the finest timber horses in America and from abroad to challenge its four grueling miles over twenty-two fences, some as high as five feet. In this picture, Phil Fanning (left) and Crompton "Tommy" Smith, Jr., demonstrate contrasting forms over a stiff post and rail fence.

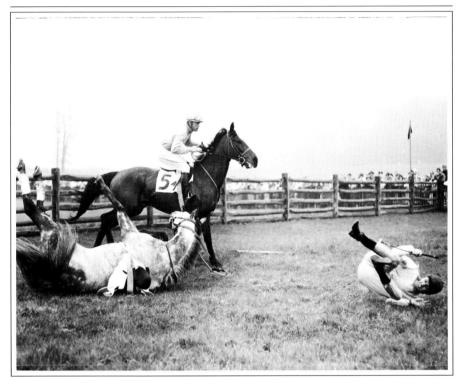

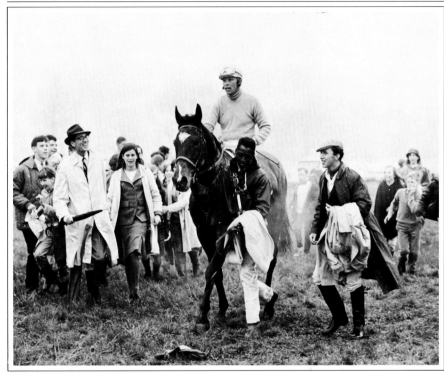

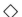

In the 1966 Maryland Hunt Cup, Crompton "Tommy" Smith, Jr., successfully avoided El Moro and downed rider Louis "Paddy" Neilson III. Jay Trump continued on to his third win in the Maryland Hunt Cup, thus retiring its Fourth Challenge Cup. This win was the third consecutive in three attempts, but not in three years. In 1965, Jay Trump took time off to race, and triumph, in the famed English Grand National steeplechase at Aintree, the top of the world in international steeplechasing.

Tommy Smith, on board Jay Trump, being led to the 1966 Maryland Hunt Cup winner's circle. Jubilation always accompanies a Hunt Cup win, but only five horses have won it three times in its ninety-five-year history. Jay Trump, a blissfully undistinguished flat racer in West Virginia, was bought by Tommy Smith for his owner, Mrs. Stephenson, for $2,000 — a modest investment for a notch on the belt of steeplechase history.

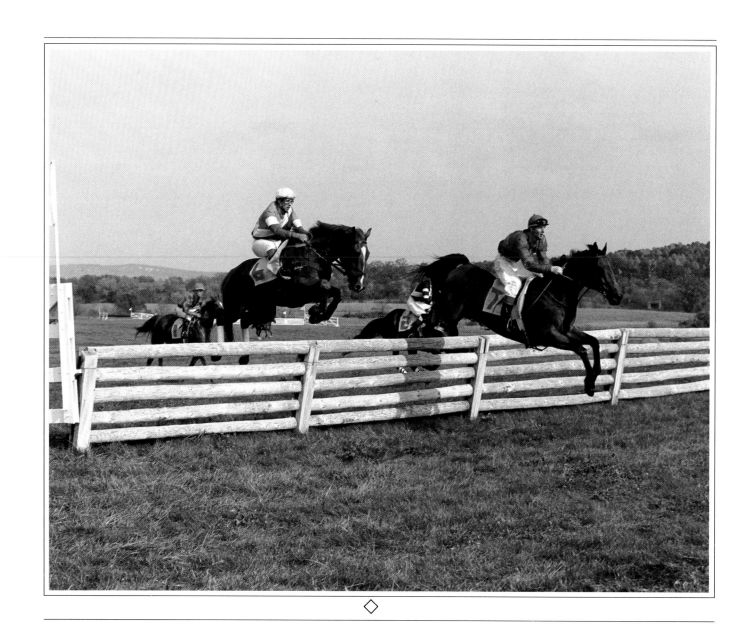

*Irene Roeckel's Ozymandias (#6) with amateur rider Billy Wofford
in the irons ensures that nary a toe will touch the lumber at the
second annual running of the International Gold Cup race at Great
Meadow, Virginia, in 1985. Douglas King on Royal Crown Stables'
Razor (#7) leads the field, but Sugar Bee (#1), owned by race course
developer Arthur Arundel and carrying famed Maryland amateur
rider Charlie Fenwick, Jr., eventually bested the lot to win this
feature race.*

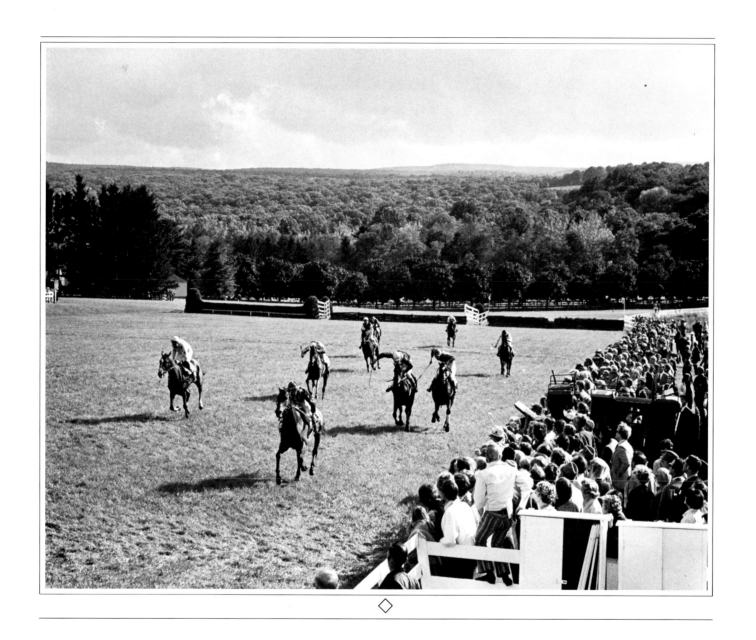

At the finish of a brush race at the Rolling Rock Races in Ligonier, Pennsylvania. Begun in 1934, the two-day race meeting spread over five days was considered by most horsemen to be the first class of steeplechase meets. Owners, trainers, officials, and riders were billeted by the organizing committee in the sumptuous Rolling Rock clubhouse and treated to days of racing, shooting, and golfing and nightly banquets and dancing. The races were discontinued in 1983, and the beautiful natural bowl cradling the race course lies fallow, awaiting a more "practical" use. Its demise ended an era unlikely to be equaled.

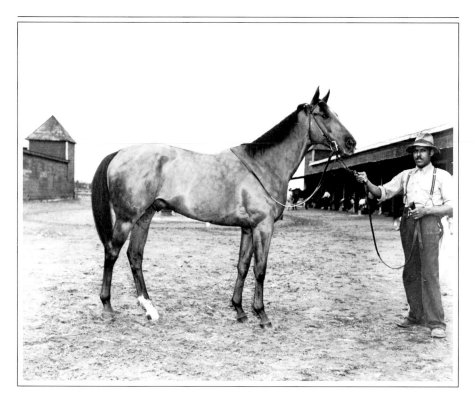

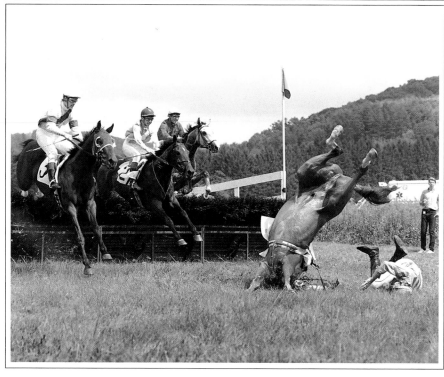

Racehorse portraits still are a staple of Hawkins' livelihood. This picture of Robert Kleberg's Assault was the first Triple Crown winner commissioned to Hawkins and was taken after Assault was retired to stud. No one can stand up a horse for portraits better than Hawkins.

Three startled jockeys contemplate avoiding a fallen front-runner at Rolling Rock Races in 1983. From left is Doug Fout (#3) on Jesse Henley's Sir Wilson; Greg Morris (#2) up on Arcadia Stables' Real Pip; John Cushman aboard Catoctin Stud's Star Billing; and Jeff Teter off James Miller's Our Flash, hoping he will finish falling somewhere in the next county. Neither horse nor jockey was seriously hurt and Real Pip went on to win the $6,000 purse.

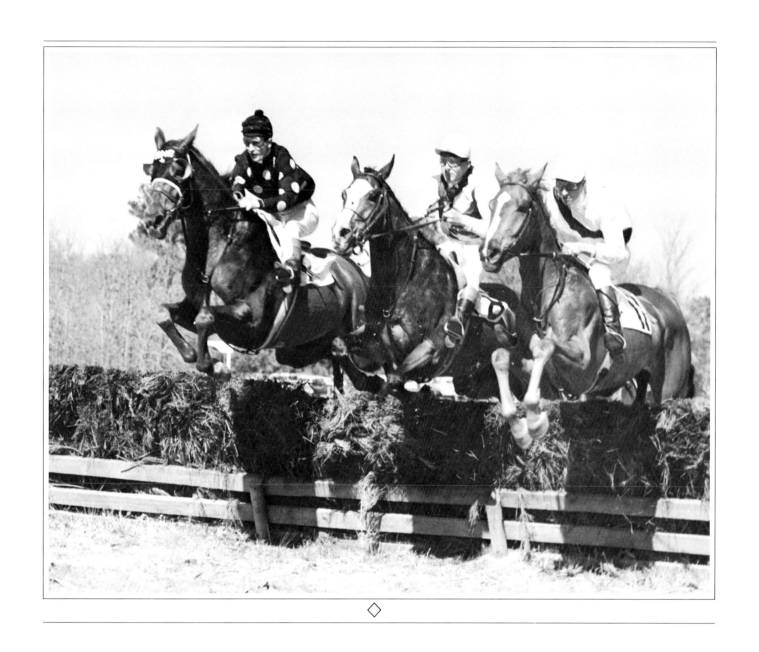

*Jumping three abreast at the Carolina Cup in Camden, South
Carolina, c. 1950. Contrasted with modern style, these riders rode
with their stirrups irons quite long, extending the rider's leg but
increasing the potential for rider interference with the horse's
natural motion. Modern jockeys ride much shorter, even over fences.*

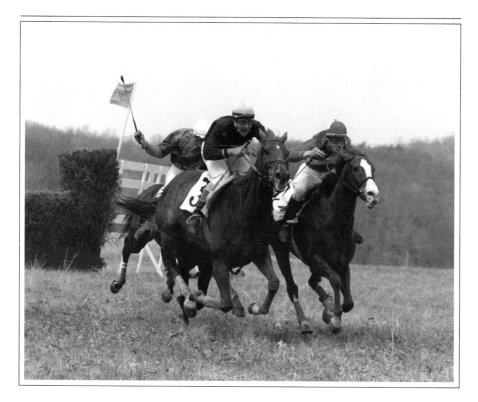

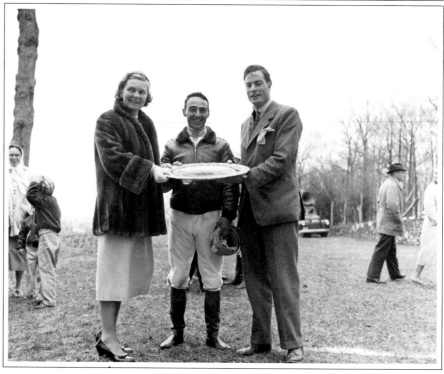

Over the last! Having successfully vanquished the last hurdle, these two jockeys drive their tiring horses, each hoping the finish line will arrive at him first. John Dale Thomas (left) and Nelson Gunnell both exude the fierce determination to win, surpassed only by the selfless hearts of their horses.

Three ever-present figures in the winner's circles of the 1950s were: Mrs. Stephen C. Clark; rider and trainer Danny Marzani; and steeplechase owner at home and abroad, George L. Ohrstrom, Jr.

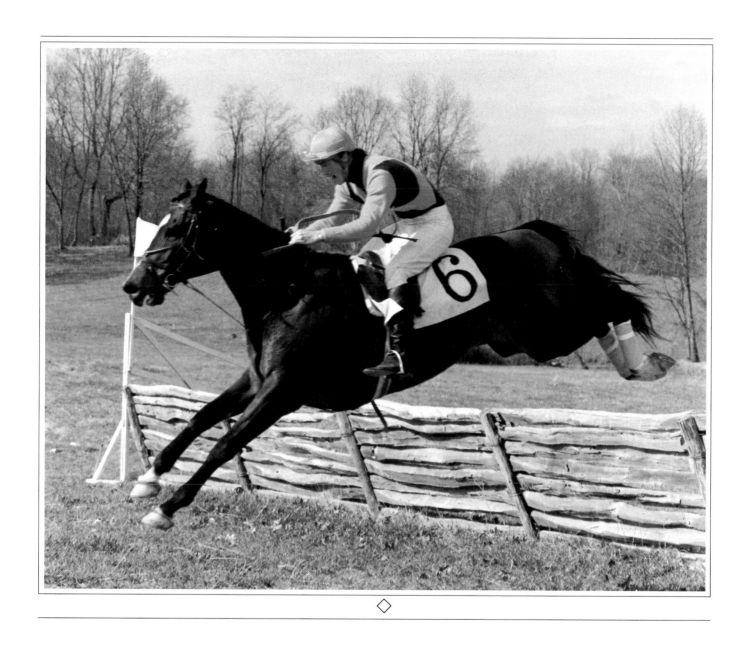

Randy Waterman's distinctive purple and yellow silks are recognized at every race meeting in Virginia. The wraps on the hind legs are padded with high-density foam rubber to protect the horse's legs from the inevitable hard raps against the wooden fence tops.

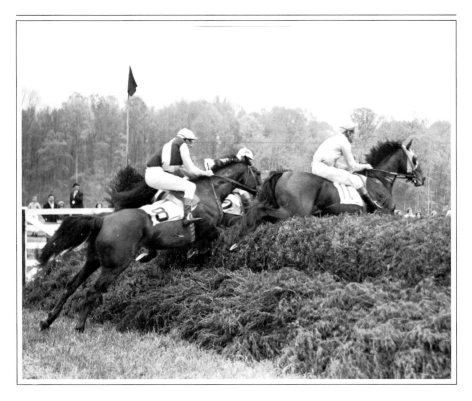

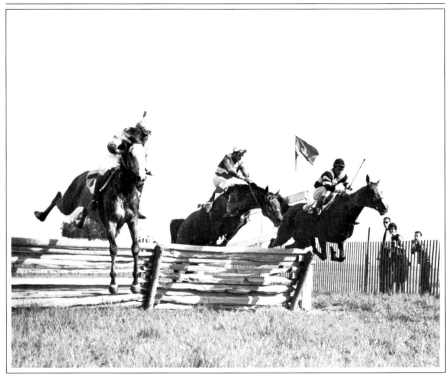

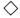

The rear view of hurdle racing has a kinetic beauty and energy. The loose rolls of cedar trees at the base of the jump provide a fullness and roundness to the obstacle, which assist the horse's eye as it measures the height and scope of this impediment to its running. Because a horse's eyes are set on the sides of its head, it basically has monocular vision and has difficulty focusing on objects directly in front. Essentially, then, a horse is blind to the object it is about to hurdle as it begins its leap. Think about it. Think about the rider!

Three ways not to take a timber fence. None of these three horses are happy campers, although all are top flight timber horses. All finished this race, but Zeke Ferguson's Leeds Don (left), with Willie Moore in the cockpit, won the coveted Virginia Gold Cup chalice for the third time and retired it. In the center is Dr. Joseph Rogers' Ballyguy, and on the right is Joe Aitcheson sitting tight on Mrs. Paul Fout's Moonrock in 1966.

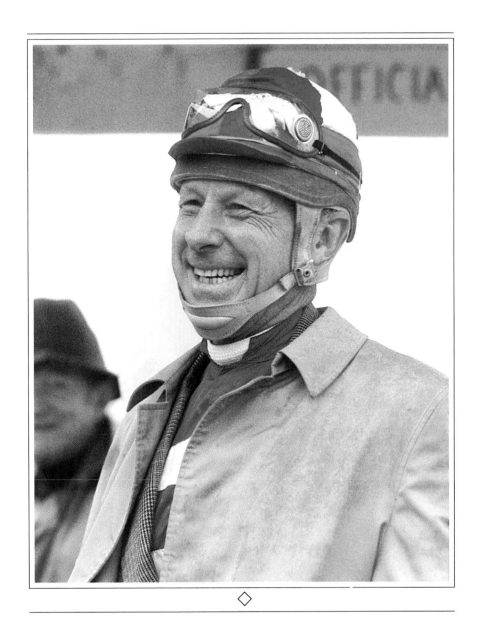

◇

The acknowledged dean of Virginia steeplechasing, Randolph D.
Rouse finally hung up his tack as a race rider at the age of sixty-
three but continues to own and train both hurdle and timber horses.
Additionally, he has been Master of the Fairfax Hunt since 1961
and annually chairs the Fairfax Point to Point Races in April.
During his time off from these various hobbies, Rouse has been a
successful commercial real estate developer in the northern Virginia
area. He has served as a president of the National Hunt and
Steeplechase Association, president of the fledgling Virginia
Steeplechase Association, and is a sought-after toastmaster
and raconteur.

Secretariat being led to the saddling paddock before the running
of the Preakness.

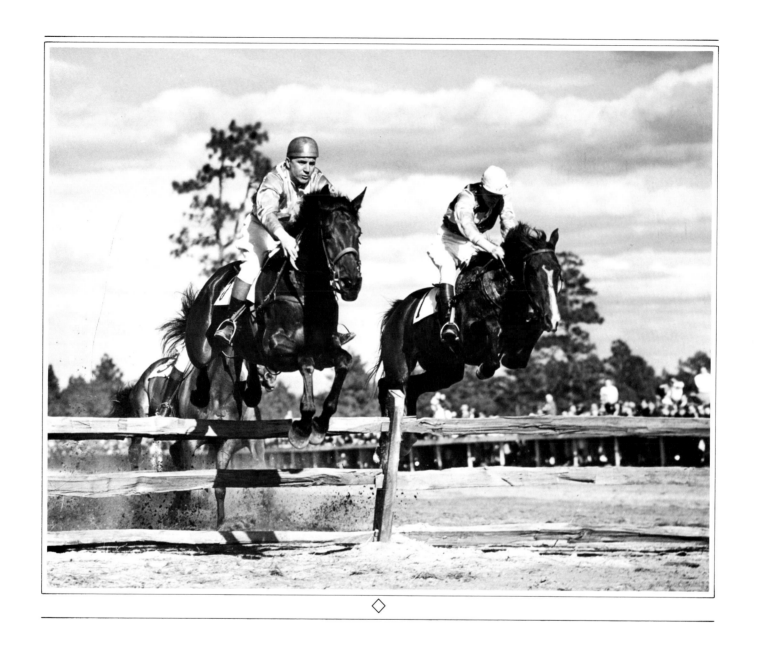

Over the boards in the sandy soil of the Stoneybrook Races of North Carolina in 1955. Race riders wear helmets of reinforced material and interchangeable silk covers, appropriate to the registered colors of their owners. The rider on the left has lost his cover, baring the smooth skullcap beneath.

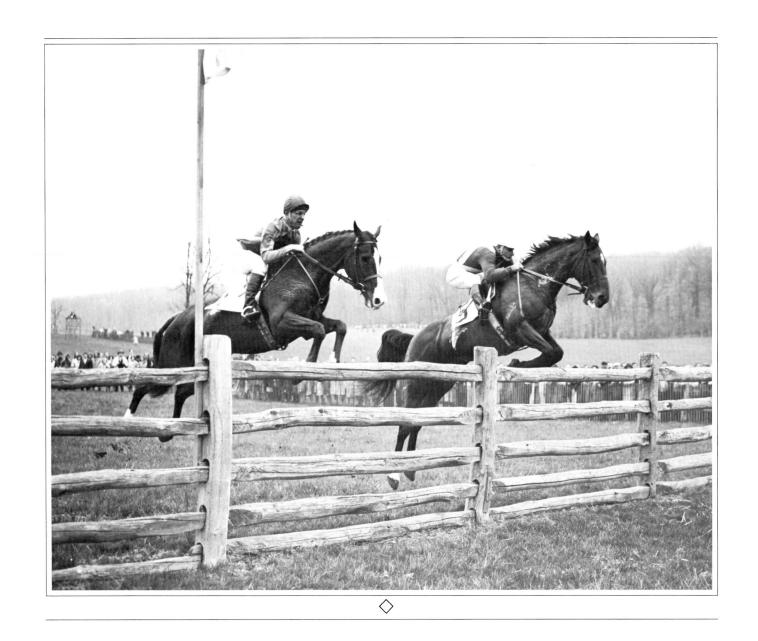

◇

One never tires of seeing a Maryland Hunt Cup photo because of
the endless variety of jumping styles, successful and failed, over its
formidable obstacles. Here, Louis "Paddy" Neilson III (1), is on a
bold jumper that has stood back on takeoff, intrepidly attacking
the fence. The other horse has gotten in too close and is laboring,
perhaps successfully, to clear the fence. Which is the happier horse
is obvious, and unhappy horses seldom win.

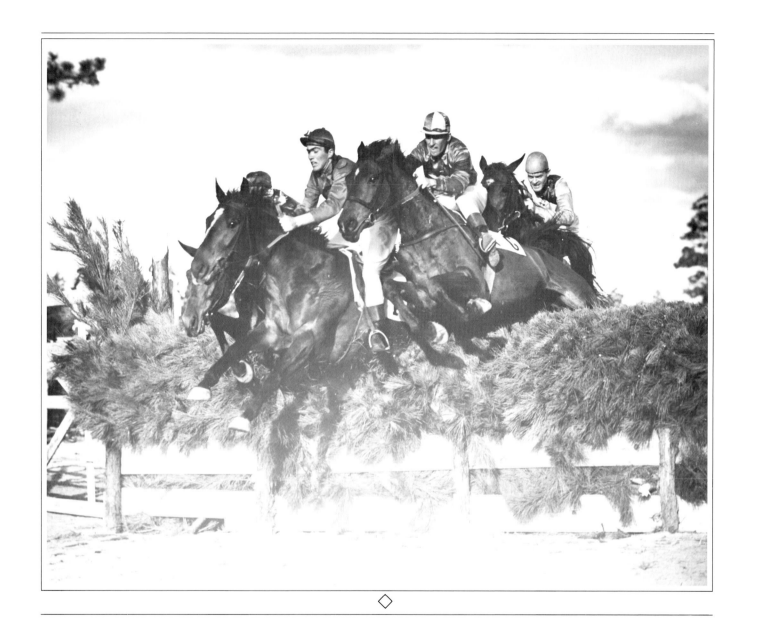

◇

A dangerously bunched quartet over the cedars at the Stoneybrook Races in Southern Pines, North Carolina. The #10 horse (second from the right) seems almost to be leaning on the lead horse to its right, a not uncommon occurrence. All three visible horses raced for the same trainer, Mickey Walsh. This picture horrified Walsh, who figured one down — all down.

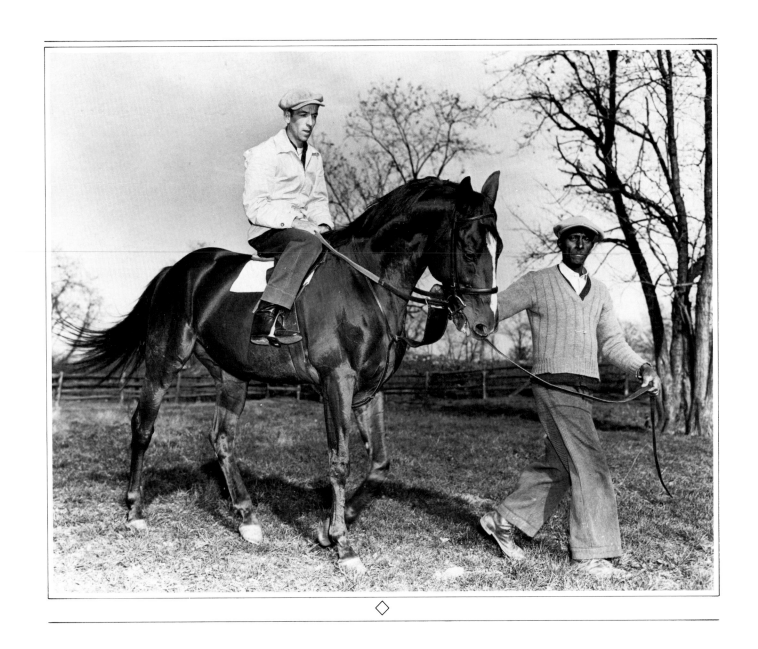

Stymie was foaled in 1941 by the King Ranch in Texas and claimed by trainer Hirsch Jacobs as a two-year-old for $1500. He went on to earn a record $918,485 while racing until the age of eight. This champion son of Equestrian is shown here while recuperating at the stable of Middleburg, Virginia trainer Jack Skinner. Tommy Field is on his back, and groom Ed Wanzer is at his head.

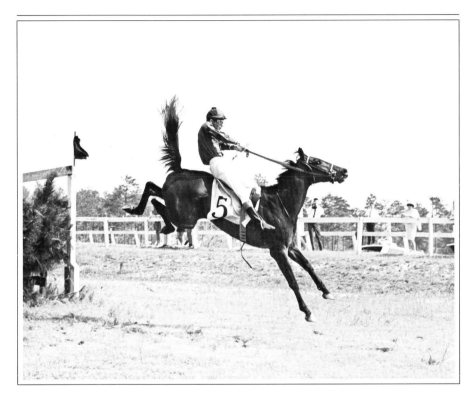

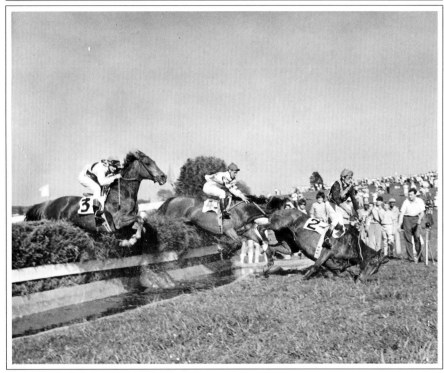

A bad jump produces a frantic effort to survive at the Stoneybrook Races in North Carolina, 1955.

Taking a header at the Virginia Gold Cup is Joe Aitcheson (#2). Falls in brush races such as this are especially dangerous since the horses move at a particularly fast pace as they ''brush'' through the obstacles. The horse immediately behind Aitcheson appears in a perilous position as well.

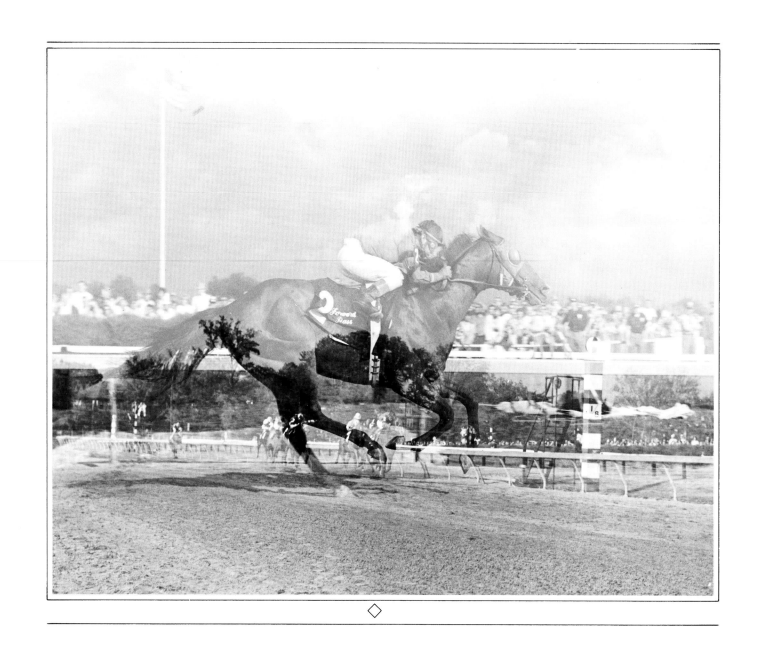

Marshall simply smiles when asked if he planned this dramatic double-exposure of Forward Pass running and winning the Preakness in Maryland.

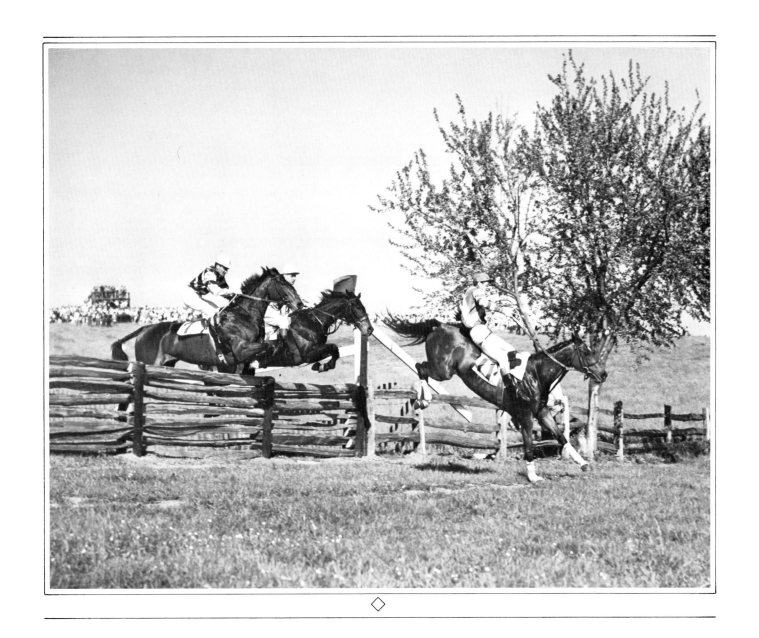

◇

*This Virginia Gold Cup race at Warrenton, Virginia, in the 1950s
included the legendary Patrick "Paddy" Smithwick in front, Dr.
Joseph Rogers between horses, and Custer Cassidy, current
illustrator for* The Chronicle of the Horse *and other publications.
A fearless rider in his day, Hawkins quotes Cassidy as coining the
phrase, "Don't shoot him, I'll ride him!"*

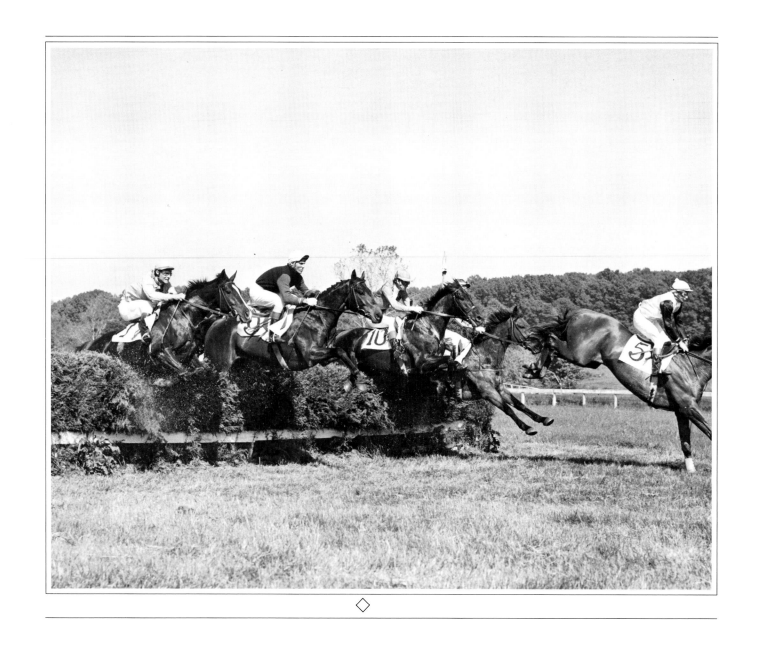

A fluid study of form and motion over a brush jump. Nearly every stage of a successful leap is shown by the horses. Also reflected here, a rider's concentration during a race is intensified by the negligible room for error and the disastrous consequences of sloppy attention.

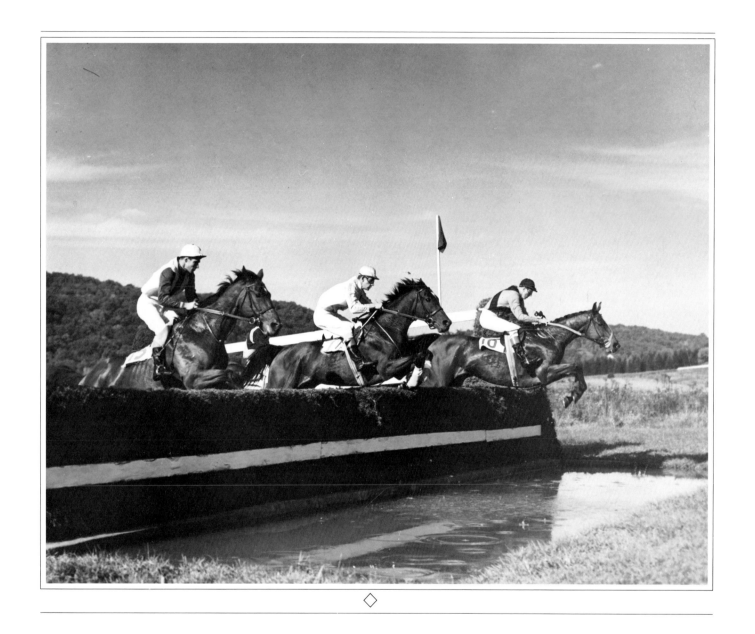

◇

Three sequential stages over a perfect hurdle jump are provided by these horses at the Rolling Rock Races in Ligonier, Pennsylvania, in the 1950s. Water jumps penalize the horse that doesn't leap horizontally as well as vertically — a fascinating concept when one realizes that the horse has no awareness of the water until after takeoff. Athletic horses will, however, stretch out in mid-air in order to clear the water.

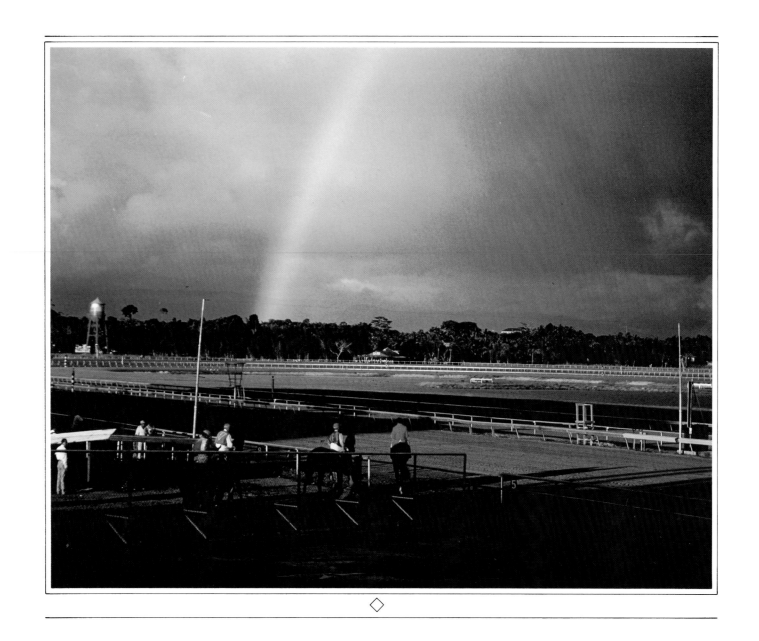

◇

Always a sucker for the unusual photo opportunity, Hawkins caught this rainbow over the Panama City, C.Z. racetrack while on holiday in 1952. Some wags suggest that the rainbow ended at Hawkins car — his traveling office and safe deposit box.

III

Show Jumping

◇

It is the perfect harmony between horse and rider; the horse giving his strength, his heart, his trust and every ounce of his athletic ability to his rider, the rider being in complete control of the horse's every movement. This is the type of performance people pay to see; it is what makes showing so popular.

KATIE MONOHAN PRUDENT, 1988

The intimate relationship between horse and rider is nowhere else more keenly displayed than inside the show ring. While equestrian expertise is obviously necessary in the hunting field and over steeplechase fences, the element of speed in those domains requires the rider to operate automatically upon the basis of natural and learned skills in order to successfully negotiate the obstacles. In the show ring, on the other hand, the rider's ability to consciously maintain a precise association of balance and oneness with his mount may well spell the difference between success or failure.

Hawkins' show jumping pictures provide exquisite studies in contrast — precisioned elegance and controlled anarchy. Precisioned elegance is typified in those classes where time plays no part and the object is to have the horse negotiate a course of smallish (three to four feet high) jumps at a pace and style characterized by their consistency. The controlled anarchy emerges as the fences get higher (up to seven feet), or when the time clock becomes a variable, but especially when both are factors. For the past fifty years, Hawkins has consistently demonstrated his talent for reproducing the spirit of both elegance and anarchy.

As he followed the amateur riders, the Pony Club children and the foxhunters showing their field hunters, Marshall honed his skills for capturing the horse suspended in its arc over the jump at just the moment when the curve of its body is most aesthetically pleasing — the ears, head, and neck anticipating the jump's completion. The horse's eye reflects the calm of confident execution as the rider's position completes the symmetry. Because the camera is so close to the action, sinew and strain, muscle and concentration are manifest in minute detail.

The jumping classes dominated by the professional riders provide a plethora of dynamic, athletic shots. These classes often contain high, fanciful obstacles, which the contestants must take at speed. If serene constancy marks the amateur classes, then frenetic grace bordering on catastrophe characterizes the "glamour" classes of Puissance, high jumping, and the like. Again, the photographic skills of camera placement, background, lighting, shutter timing, and composition combine to produce vignettes of incomparable power, detail, and excitement.

A favorite site for horse shows during the 1940s was the Bath County show grounds adjoining The Homstead resort spa in Hot Springs, Virginia. Here, Shirley Payne guides one of Mrs. "Billie" Greenhalgh's horses over a natural cedar brush pile, c. 1941. The soft or straw fedora was a familiar headgear for gentlemen in other than appointments classes. Now, for obvious safety reasons, an approved, reinforced hard hat is required of show jumpers.

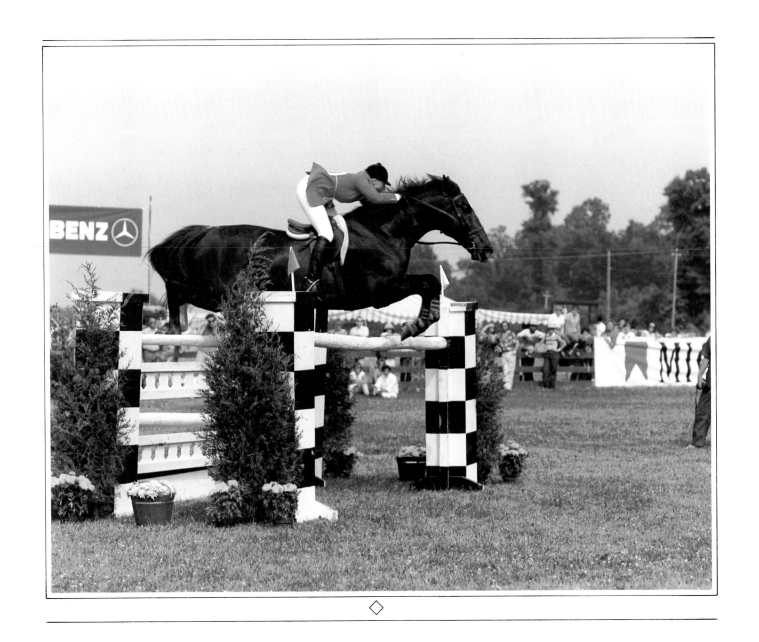

*Racing against the clock at the 1982 Upperville Jumper Classic,
Katie Monohan Prudent clears a double-oxer on Jethro. This event
helped her win the title of the American Grand Prix Association
Woman Rider of the Year.*

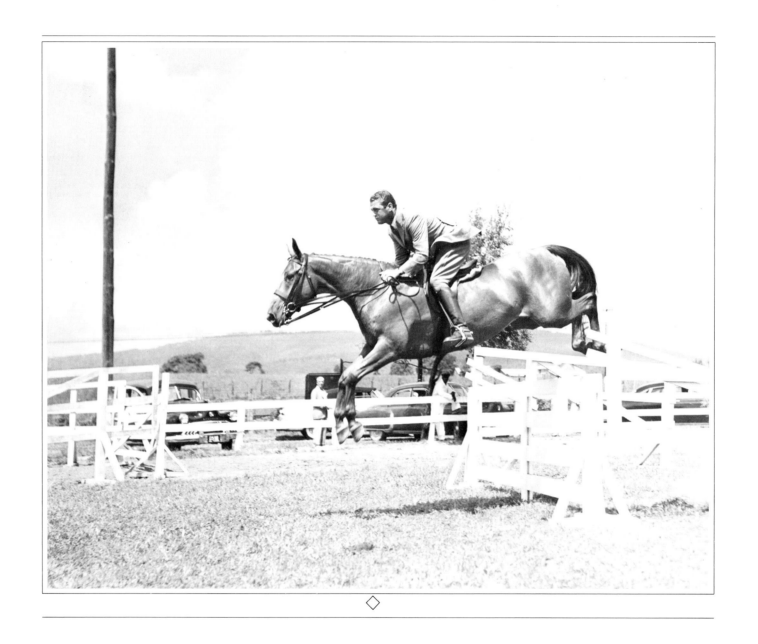

◇

Morton W. "Cappy" Smith has been a central figure in the show jumping world for over fifty years. A master horseman, he automatically garnered spectators' attention and applause whenever he entered the show ring. Smith led the Orange County Hunt field as M.F.H. from 1971 to 1979. Now in his 70s, Cappy continues to breed, break, and train for the show ring, and is an acknowledged authority on all aspects of horsemanship.

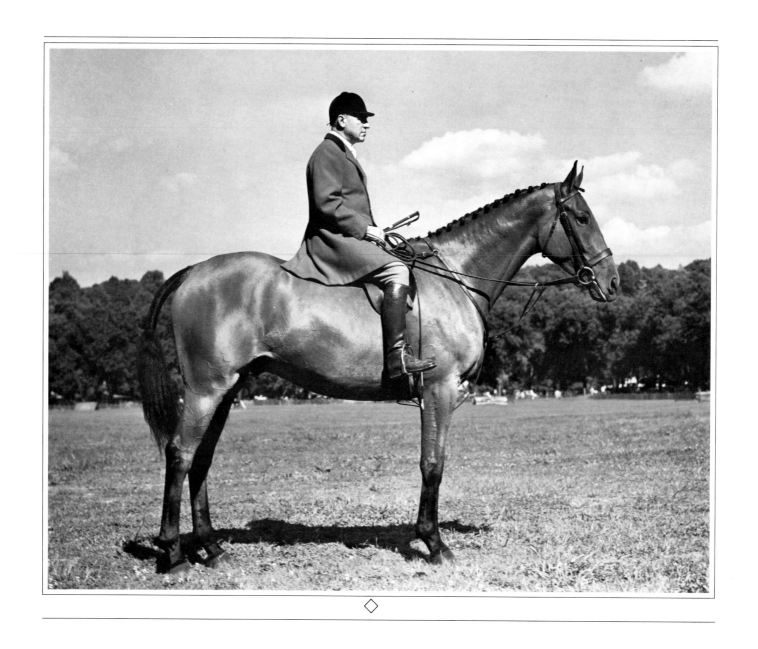

*Former Secretary of the Treasury George M. Humphrey on
Richmond Boy at the 1951 Chagrin Valley Horse Show. Humphrey
is an ex-master of the Chagrin Valley Hunt.*

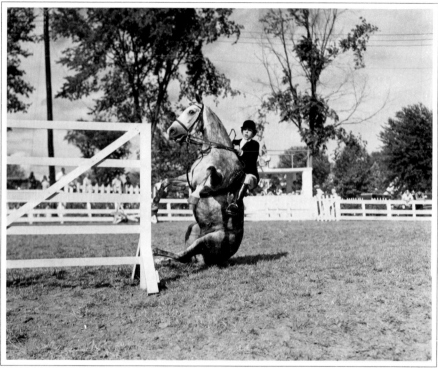

Thirteen-year-old David Ziff of Dallas won the 1985 U.S. Grand Prix at Dallas, besting all of the adult professionals. His proud parents stand just below him.

Show jumping has its share of dangerous disasters, although these two appear more startled than imperiled. According to Hawkins, the horse began to refuse as it approached the jump, lost purchase on the slick grass, and slid to this ignominious position.

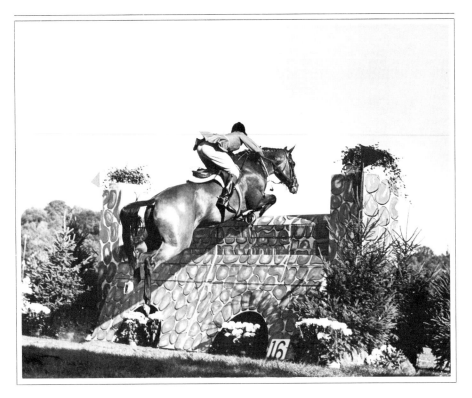

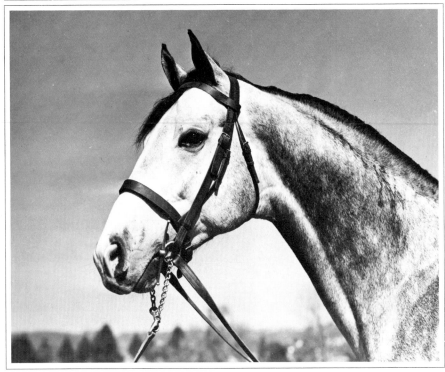

<div style="display:flex">

Courage is the only word to describe the willingness of horse and rider to jump an obstacle neither can see over. Here, famed rider Rodney Jenkins and Sure Thing negotiate a seven-foot wall at Ohio's Chagrin Valley PHA Show in 1967. The "wall" is constructed of lightweight wooden bricks, which scatter if struck by the horse.

The classic head of the seminal show sire, Kiev's Umber. His offspring include son Bard Umber and grandson Braw Umber. Kiev's Umber was owned by Frederick Warburg and stood at Mrs. William Howland's Land Ho Farm, where he is buried. Mrs. Howland currently owns and stands Braw Umber.

</div>

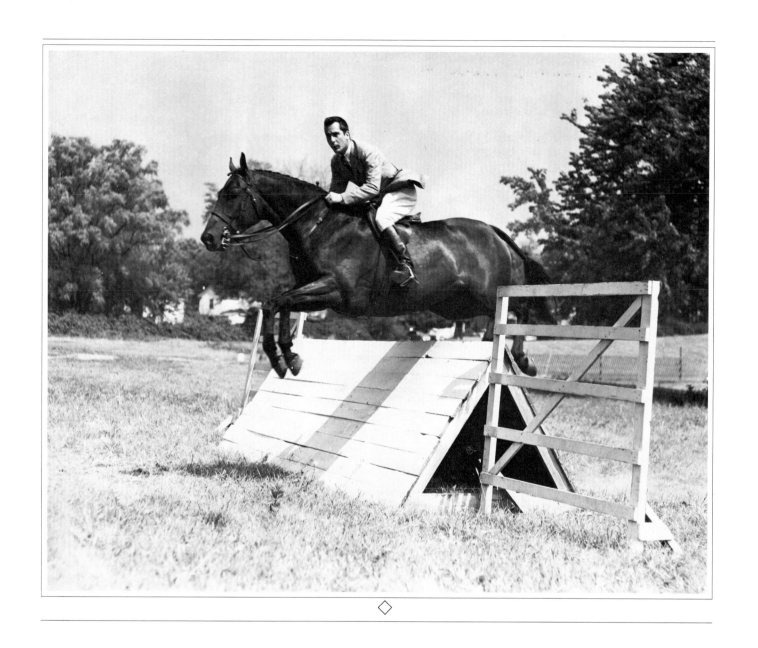

A consummate show rider and trainer, Bobby Burke always sat his horse quietly, but the concentrated look of determination on his face became a trademark. Warrenton, in the 1950s.

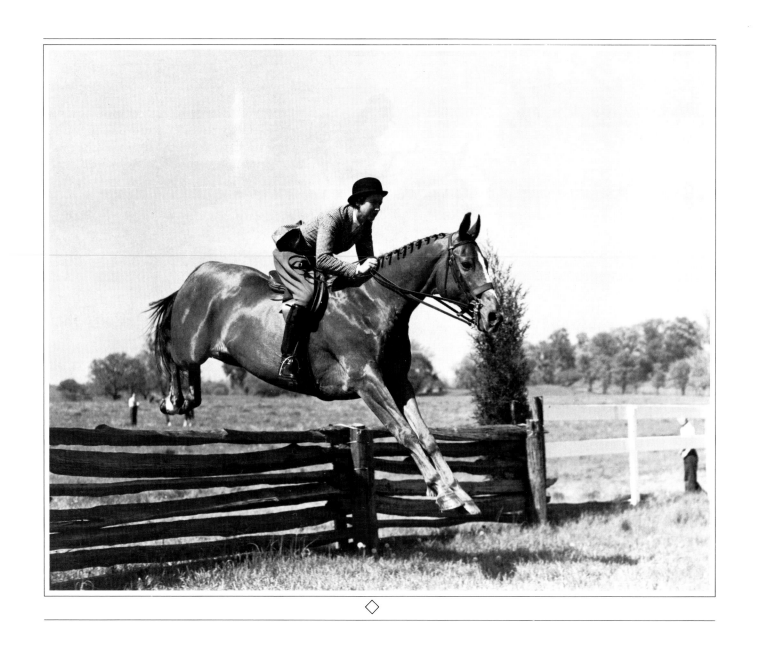

Sallie Wheeler, c. 1965

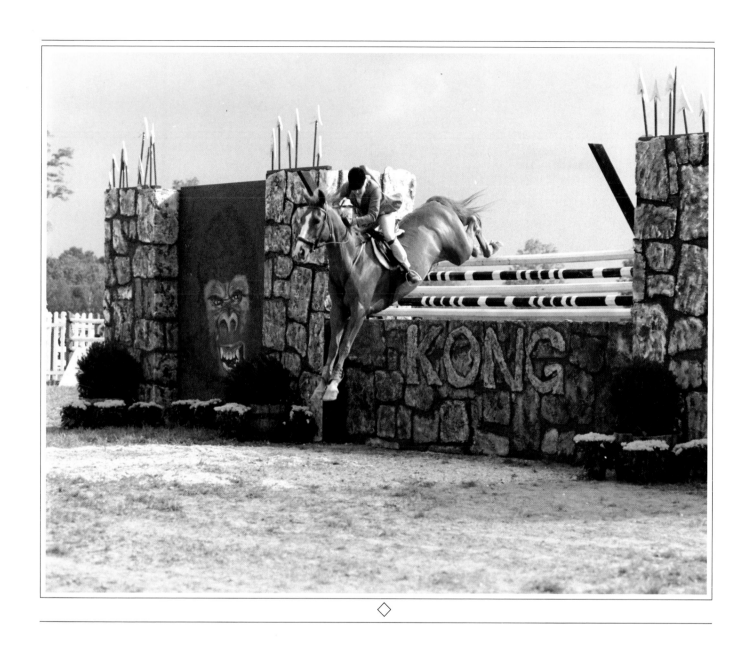

"Precisioned elegance and controlled anarchy" characterize Grand Prix jumping. High, fanciful obstacles, such as this six-foot-plus wall, test the prowess and will of both equine and human athletes, and also provides a steady stream of spectacle to ringside viewers.

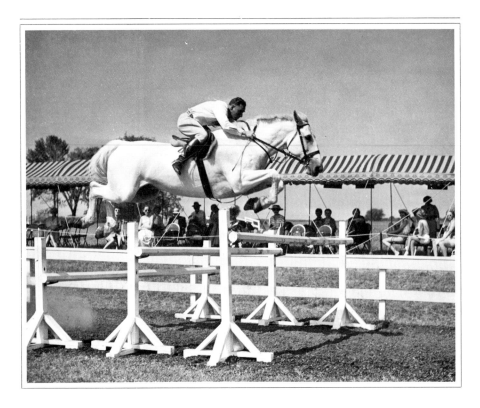

A spread jump such as this requires the horse to approach the obstacle with some speed, resulting in a flatter arc over the fence. This nicely tucked up gray is being piloted by Dave Kelly at the Skaneateles, New York show, c. 1950.

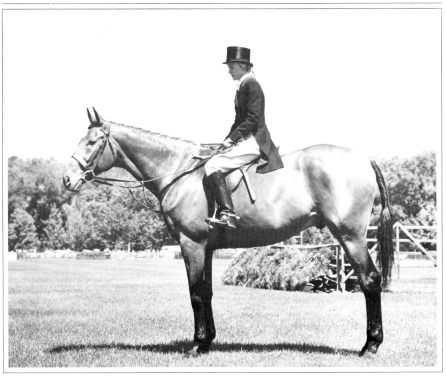

Margo Humphrey atop The Sky at the Chagrin Valley, Ohio Horse Show in 1960. While modern, synthetic stretch breeches may be formfitting and washable, they don't have the flair of these traditional "pegged" breeches.

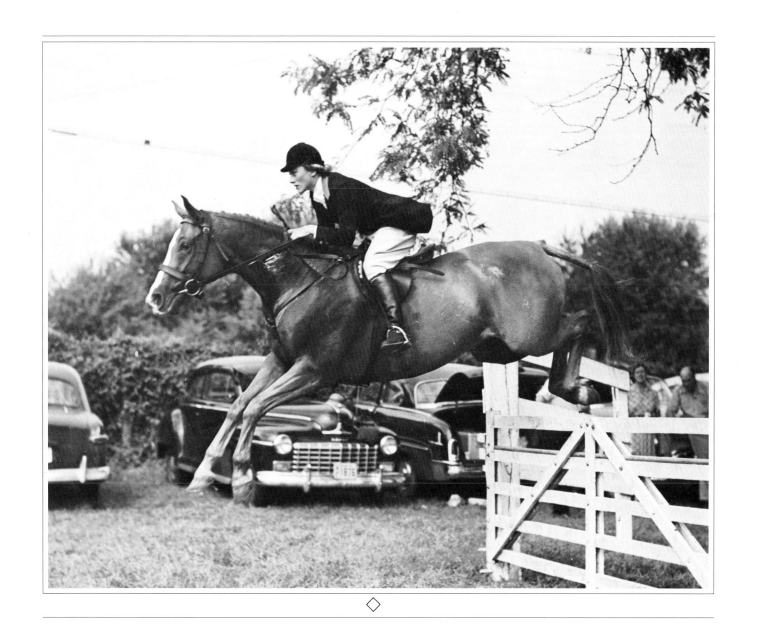

Betty Perry in an appointments class at Warrenton, Virginia in 1950. "Appointments" refers to the apparel, equipment, and tack required for entries in certain classes. An excellent example of proper appointments here are the white string rain gloves carried under the skirt of the saddle, with just the fingertips showing.

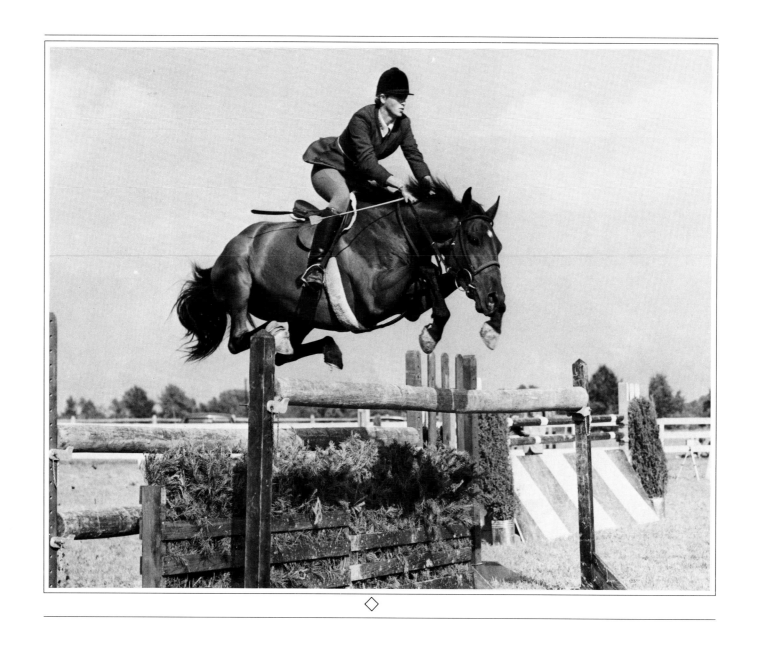

"Frenetic grace bordering on catastrophe" accurately defines the moment facing this pair. While the rider might seem oblivious, the horse's expression reveals its total understanding of the term "sticky wicket." Moments later there was plenty of firewood where the jump had stood.

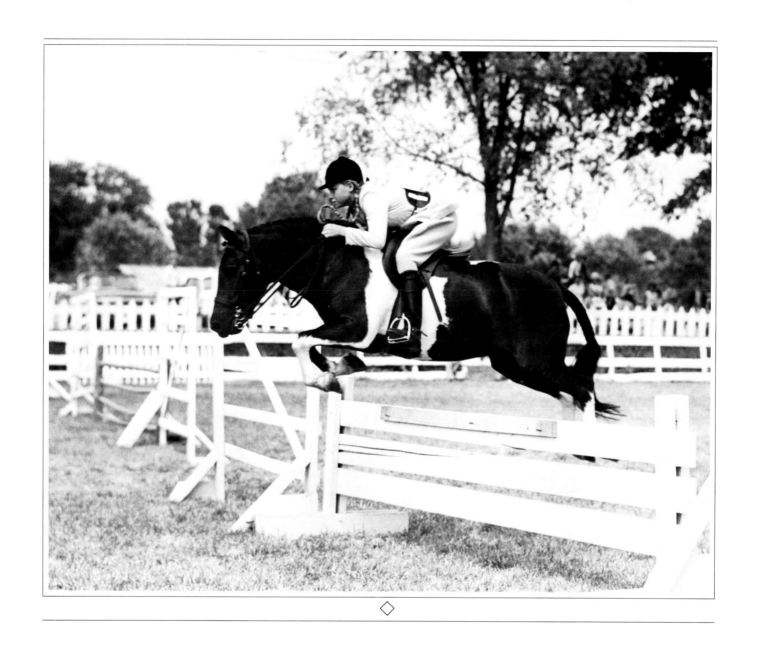

◇

The Warrenton Pony Show has provided a forum for generations of young riders to develop since 1920. This show is also unique in that it is totally managed by the youngsters, so added to the lessons of horsemanship and sportsmanship are responsibility and management. Loci Van Roijen and her flashy pony neatly sail a plank fence, c. 1970.

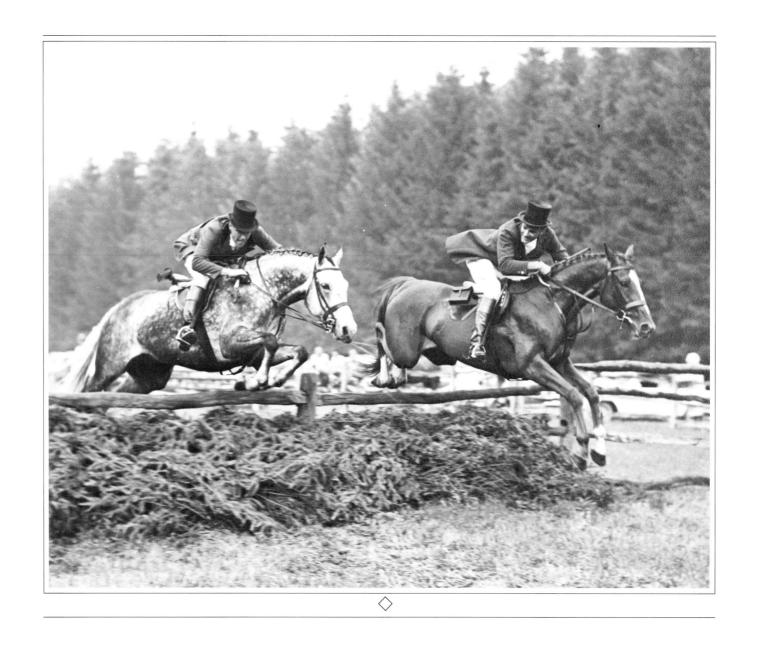

A polished looking and performing hunt team is Dan Creary (left) and Paul Fout at Rolling Rock in Ligonier, Pennsylvania, in the early 1960s. Hunt teams compete over an outside course that attempts to simulate hunting conditions. Horses are judged as teams on hunting pace, manners, performance, and, sometimes, appointments. Oftentimes they are required to jump the last fence side by side, as here.

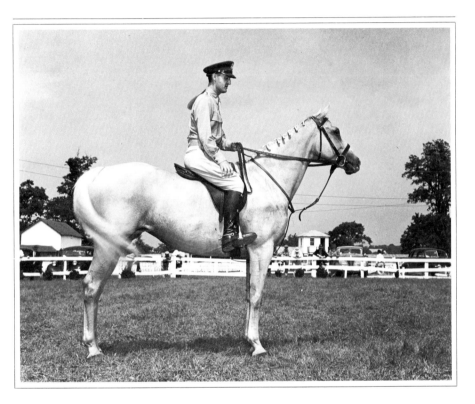

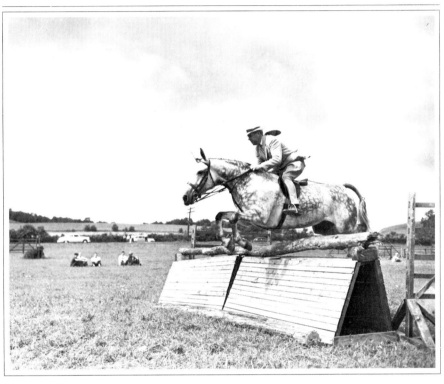

Paul Mellon, on furlough from the U.S. Cavalry during World War II, paused before entering the ring at the Warrenton Horse Show.

Michael "Mickey" Walsh aboard a dappled and athletic gray at a hunter trial in Southern Pines, North Carolina, c. 1950. Walsh, an Irish import to this country in 1923, has been a giant in steeplechase, flat racing, and showing circles. A founder of the Stoneybrook steeplechase races, he also shares the record for the most Carolina Cup victories (seven) with his fellow steeplechase trainer, W. Burling "Burly" Cocks.

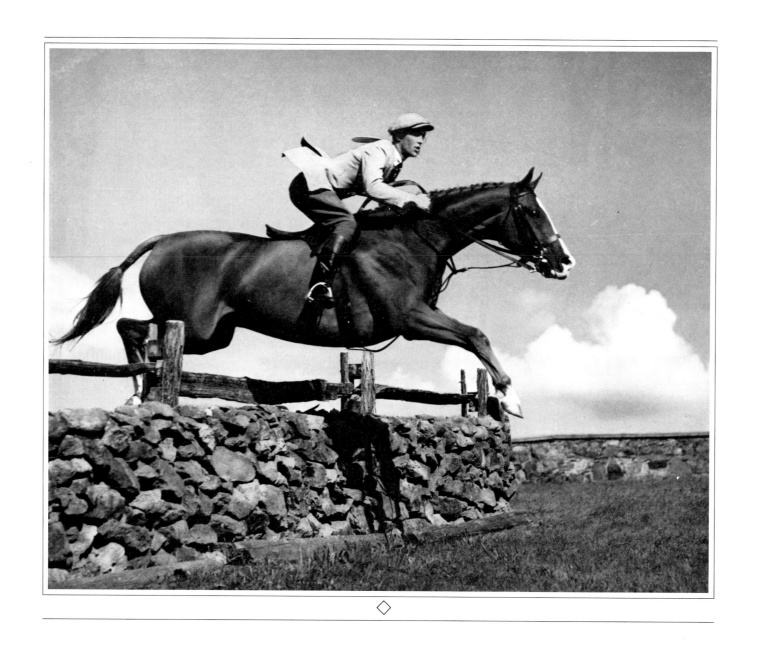

◇

Alex Calvert, 1941

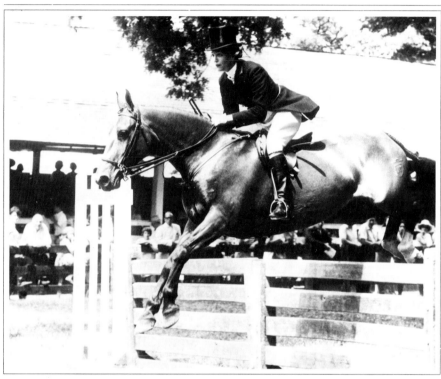

Nothing is more pleasurable to watch than a child and her pony happily making their round in a jumping class. Here, both Penny Jennings and her keen gray are fairly beaming as they compete at the old Culpeper, Virginia, show, c. 1941.

"Under the oaks" at Upperville, Virginia, in 1965, Sallie Wheeler of Cismont Manor Farm, Keswick, Virginia, shows her mare Isgilde to perfection. Sallie and her husband, Kenny, have been highly respected show riders and trainers for more than 25 years. Each year they commission Hawkins to provide portraits of their horses and those of their clients.

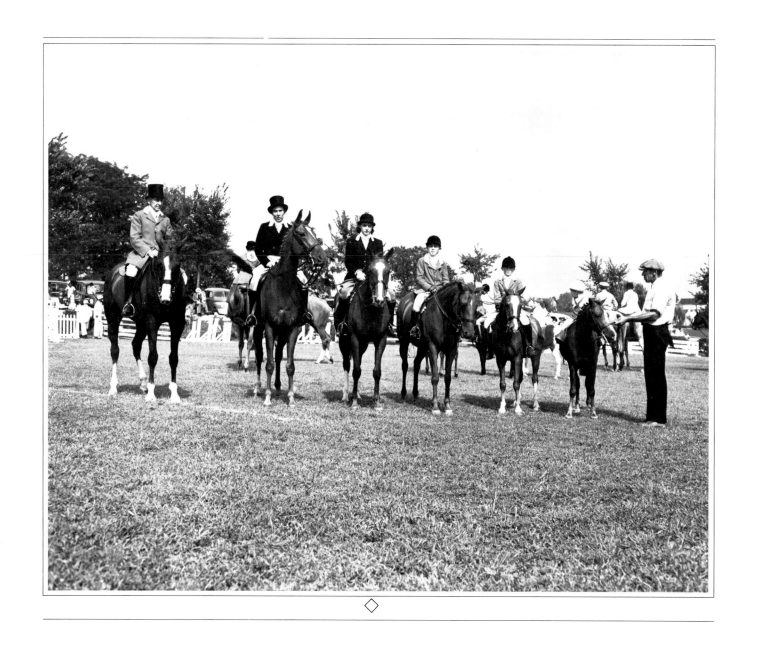

The family class was once the jewel in the crown of every successful horse show. At the Warrenton Horse Show, c. 1950, is the family of Julian Keith (far left), father of Peggy Keith Hamilton (next from left), mother of Pickens (third from left), sister of James (third from right), brother of Barry (second from right), brother of inquisitive and nonchalant Gillis (far right).

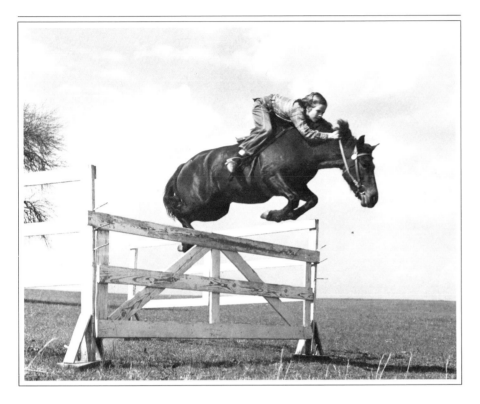

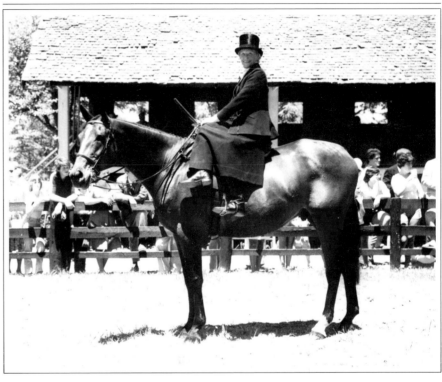

◇

◇

A fearless horsewoman, even as a child, Eve Prime (Mrs. Paul Fout) schools her pony, Spoogie Woogie, in an open field. Eve's entire family is immersed in the equestrian world. A respected equine artist, she hunts, shows, and owns racehorses with her trainer husband, Paul. Son, Doug, is a steeplechase rider and trainer while oldest daughter, Nina, is a top level event rider. Youngest daughter, Virginia, is a Pony Clubber who fox hunts and shows.

Certainly some of the most enjoyable and colorful events in any show, sidesaddle classes are vestiges of a bygone era since few women regularly fox hunt aside. The style has shown a resurgence in recent years within the show ring, however, and to win a class at Upperville is a special source of pride. That emotion is clearly evident on the face of Diana Drury Norris after winning on her field hunter, The Oyster, in 1979.

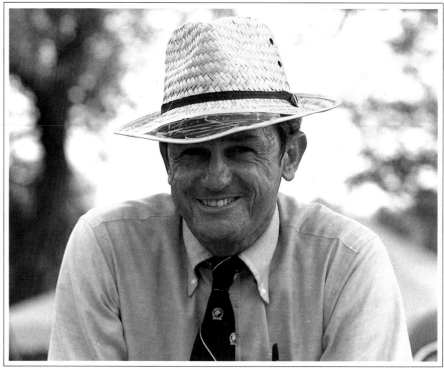

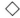

Clarence "Honey" Craven, longtime fixture as the manager and ringmaster of such top shows as Devon and Madison Square Garden in New York City.

The late A.E. "Gene" Cunningham was a perennial show winner on his famed Cap and Gown in the mid-'60s. This affable gentleman's sudden death stunned the show world, and the Gentlemen's Hack Class at the Warrenton Horse Show, now named in his honor, annually is filled with his friends and former competitors.

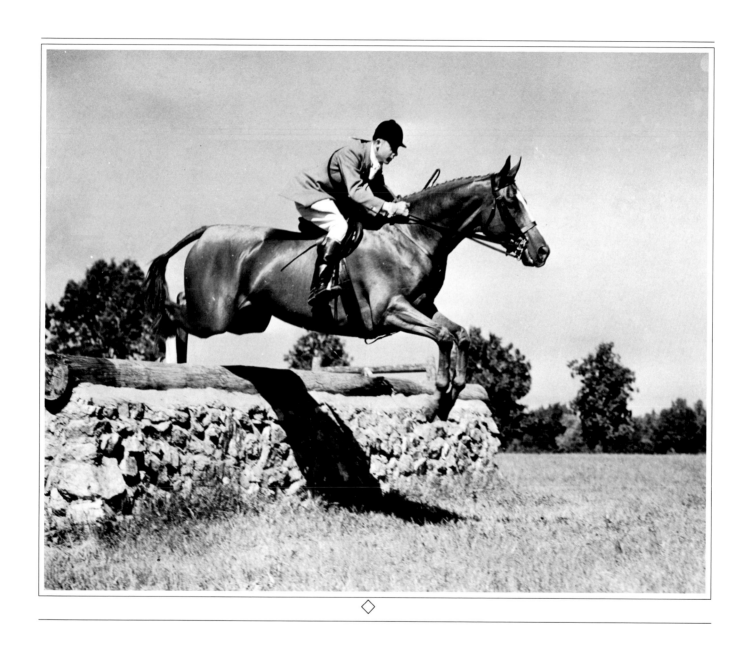

Virginia's Noel Twyman takes a stone wall in the 1965 Deep Run Hunt Horse Show. Notable here is the absence of guide wings for the jump, requiring a steady and eager jumper to score well. While a split-second earlier shutter release would have provided a more flattering silhouette of the horse, this picture is a stunning example of an athletic pair in perfect collaboration. The horse's ears and eye are attentive, the lips and neck relaxed. Twyman has a soft but definitive touch on the reins, and his body is perfectly in balance with his horse's center of gravity.

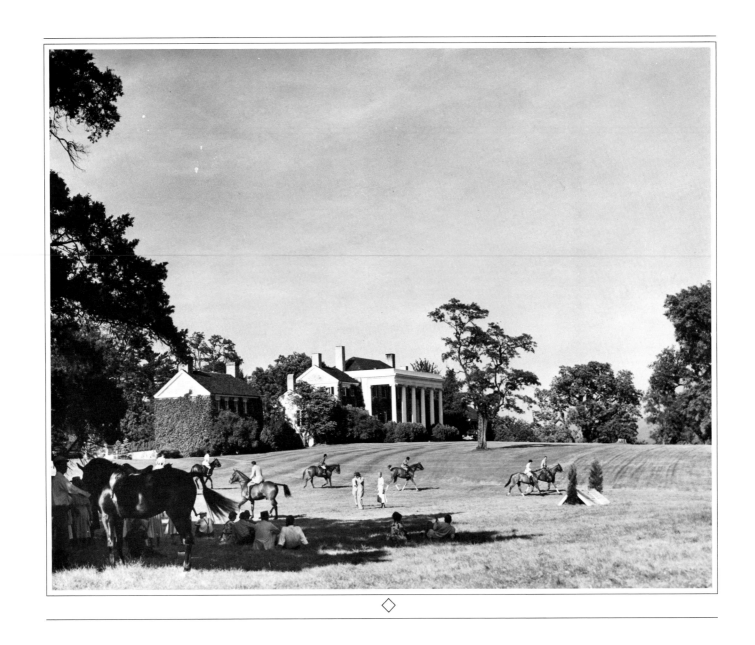

Carter Hall mansion near Millwood, Virginia is the locale for many equestrian events and is a favorite haunt of Hawkins. This local show was in 1965.

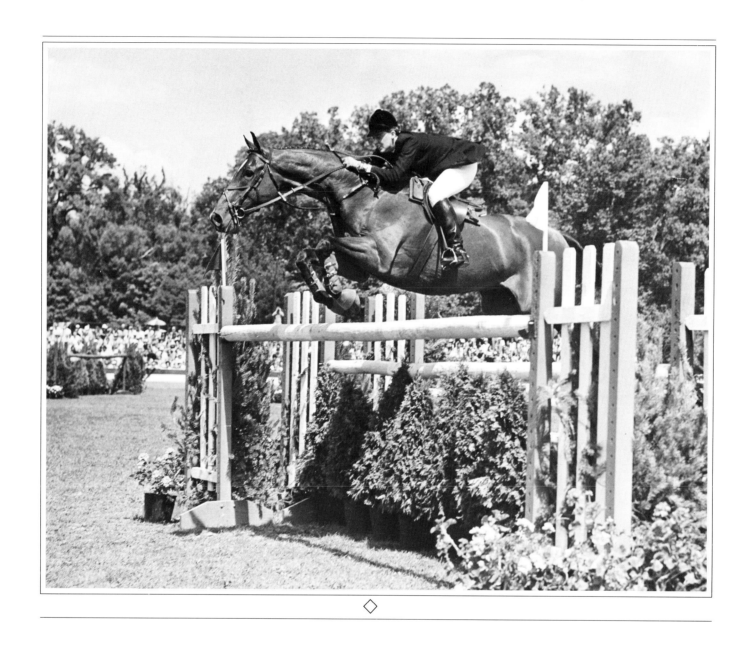

◇

This unidentified pair displays exemplary form and balance. Of interest too, is the lead pad visible under the rider's saddle which serves to equalize the jumping conditions among competitors of different weights.

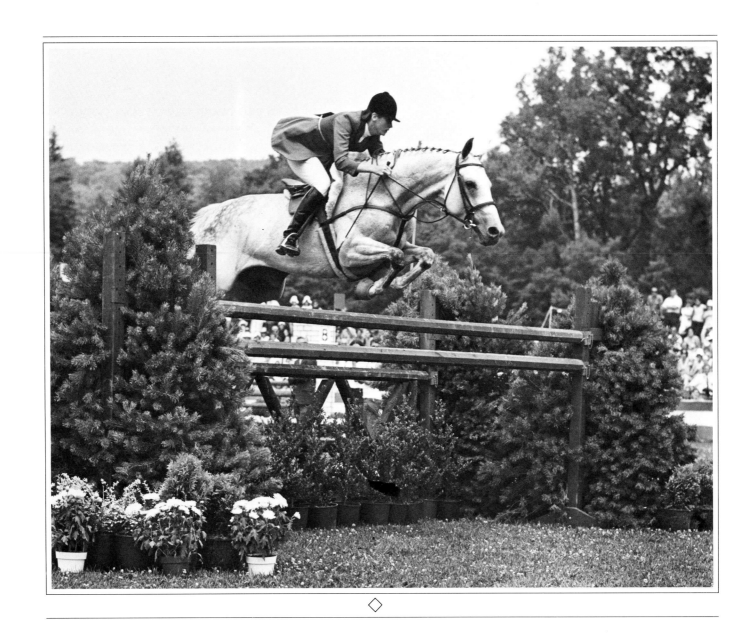

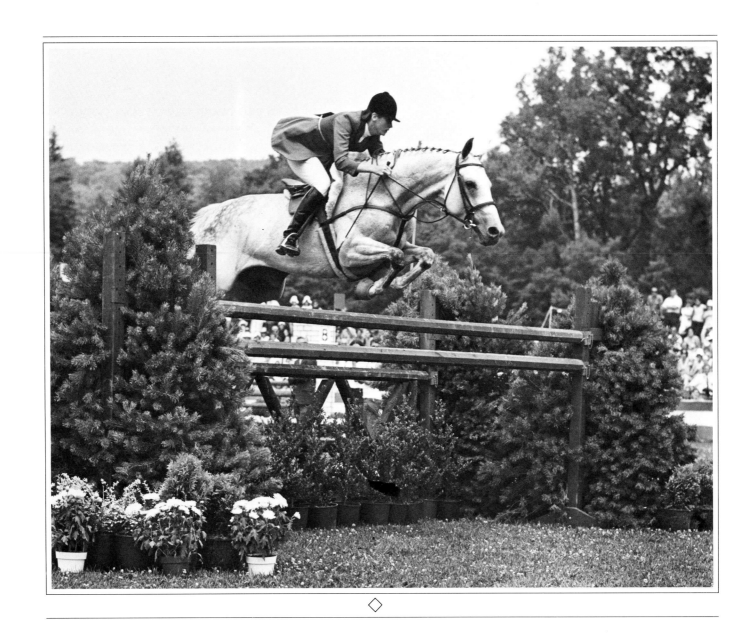

Mary Mairs Chapot shows her top-level form over a double-oxer
at the Professional Horsemen's Association Show in Cleveland,
c. 1978. Her horse's front legs couldn't be "tucked up" any tighter
— the mark of an excellent jumper. Wife of Olympian rider,
Frank Chapot, Mary also became a member of the Olympic team.

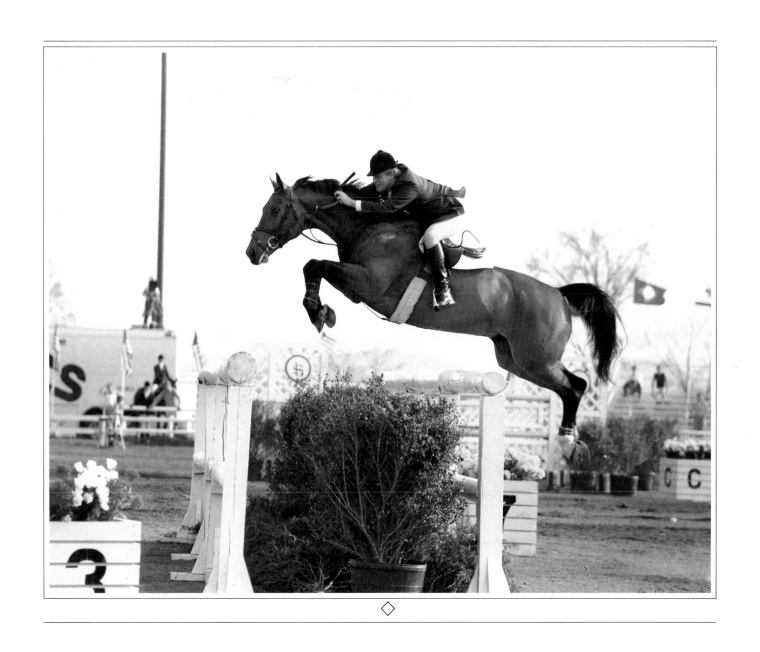

◇

Talent worth $1,000,000! The jumping genius of The Natural speaks for itself, and led to his sale for the above amount. Master rider Rodney Jenkins can create equal excitement, and the combination produced this win at the Grand Prix at Commonwealth Park in Culpeper, Virginia.

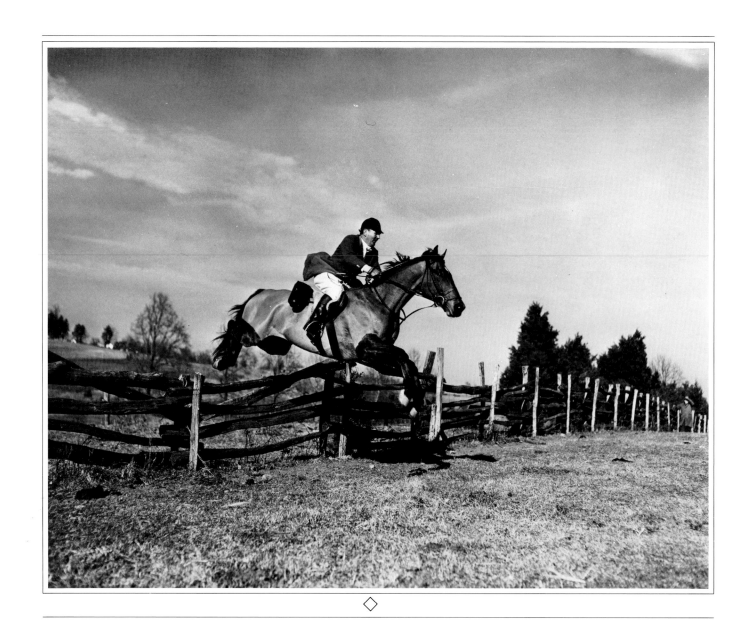

◇

Competing in a Farmington, Virginia hunter trial around 1950 was then-Huntsman and Joint-Master Grover Vandevender. The leather pouch attached to his saddle contained farrier tools and other equipment necessary for emergency situations in the hunting field. As is customary during the fox hunting season, (September through March), this horse has been given a full body clip. Only his legs have been left long for protection against briars and brush.

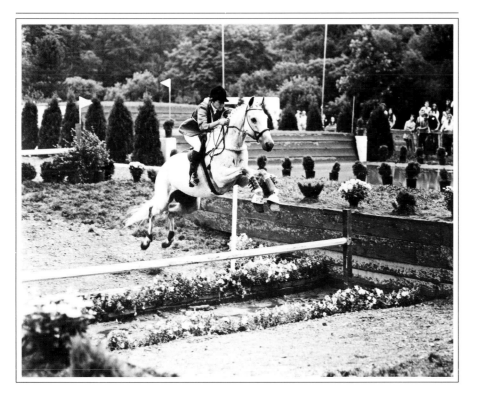

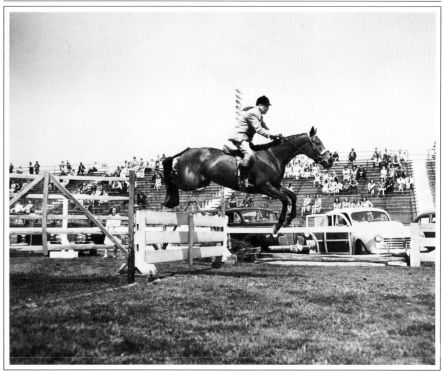

*U.S. Equestrian Team member Kathy Kusner flies "Pullman's
Grave" water jump on Aberali at the 1972 Chagrin Valley PHA
Show. Notice that Aberali has no bit in his mouth, wearing instead
what is called a hackamore. Used for a variety of reasons, it
requires, especially in competition, a particularly good rider and
a sensitive, well-schooled horse because the horse's steering comes
mainly from the rider's use of leg and balance. When one realizes
that this was a timed event, Kusner's and Aberali's talents
seem phenomenal.*

*One of Hawkins' earliest showing photographs, this was taken at
the Lynchburg Horse Show in Virginia before World War II and is
of Marshall's longtime friend, David Hugh Dillard.*

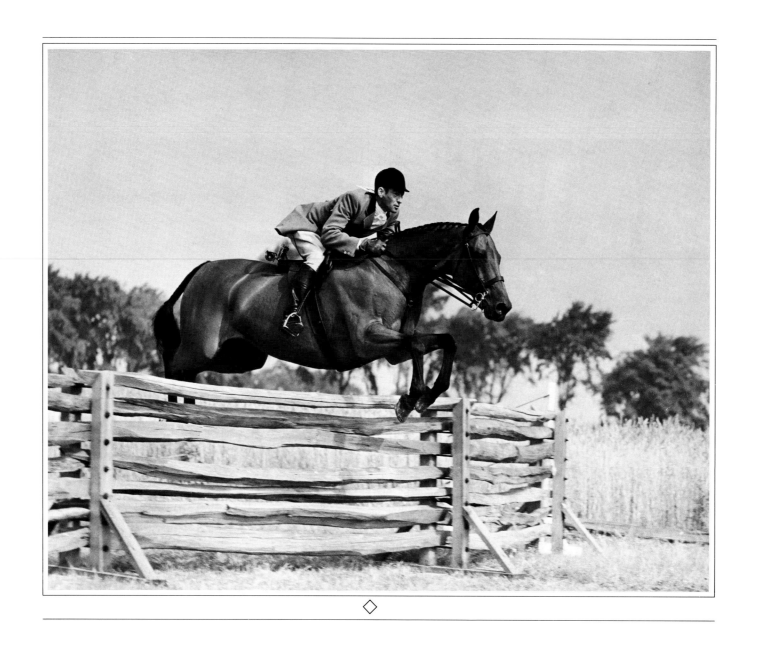

Raymond Burr (no relation to the actor) and his elegant horse display "serene constancy" over a four-foot post and rail at the 1951 Skaneateles, New York Show. As a hunt whipper-in, Burr wears a set of hound couples attached to his saddle as part of the required equipment for this class.

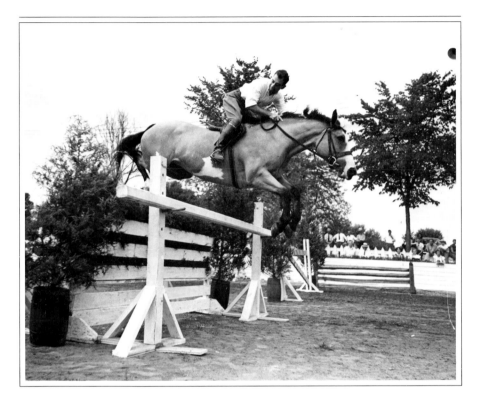

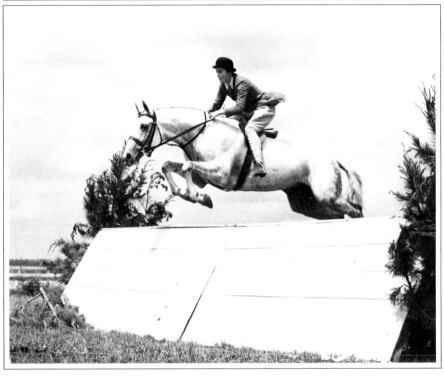

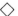

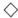

Bert Firestone easily clears a double-oxer jump aboard the distinctively marked Golden Chance at Warrenton, Virginia in the early '50s. This highly successful jumping mare was discovered while toiling as a Sweet Briar College school horse.

Mrs. Elizabeth Altemus Whitney Tippett jumping her famous gray, Bon Nuit, over a chicken coop at the Sedgefield, North Carolina show in the 1940s. It was Liz, then wife of John Hay "Jock" Whitney, onetime ambassador to the Court of St. James, who first discovered Hawkins at a Lynchburg, Virginia horse show in 1939. She had an enormous string of show horses then, and thus began a career and friendship that endures to this day.

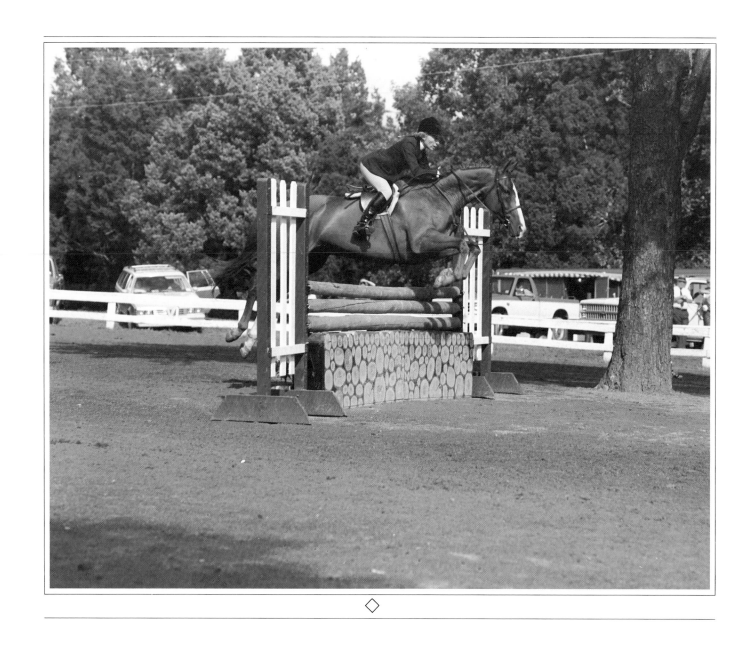

◇

Two masters of the show ring are Warrenton, Virginia's Betty Oare
and her amateur-owner champion, Spirit of Song. At the Keswick,
Virginia Show, c. 1982.

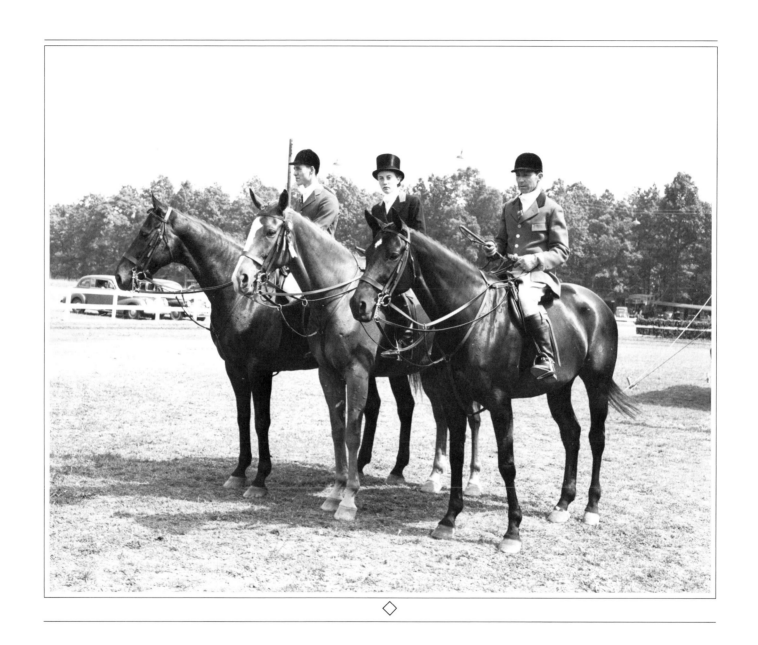

*One of the finest hunt teams in the show world during the 1940s
was this trio riding out of George Watts Hill's Quail Roost Farm in
North Carolina. (Left to right) Dickie Kelly of Richmond, Virginia
on Balconian; Sue Schley Burke on Lucky Buck; and Delmer
Twyman of Gordonsville, Virginia on Inky. A careful study of this
picture shows a team with the finest style in the old tradition
of showing.*

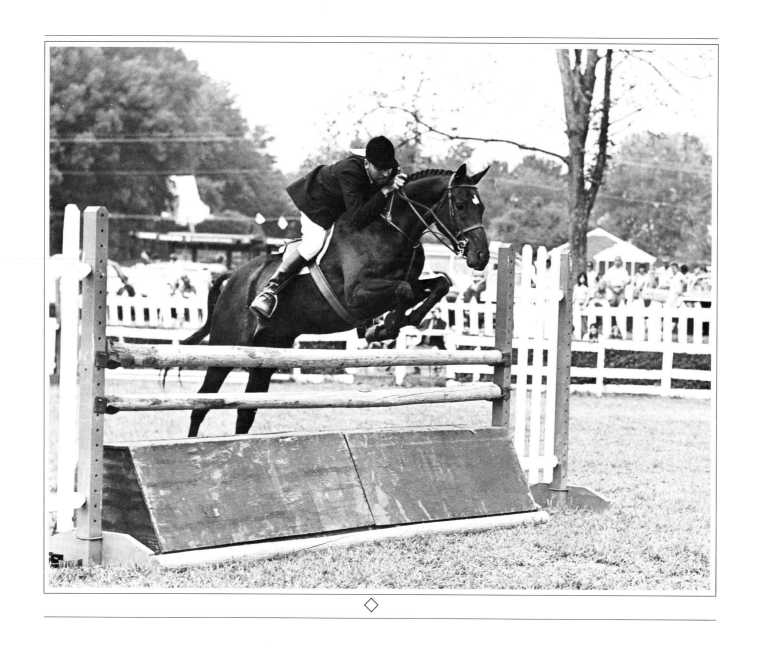

◇

Kenny Wheeler of Cismont Manor Farm, near Charlottesville, Virginia, at the Warrenton, Virginia Horse Show. He and his wife, Sallie, are in considerable demand now as show trainers and judges.

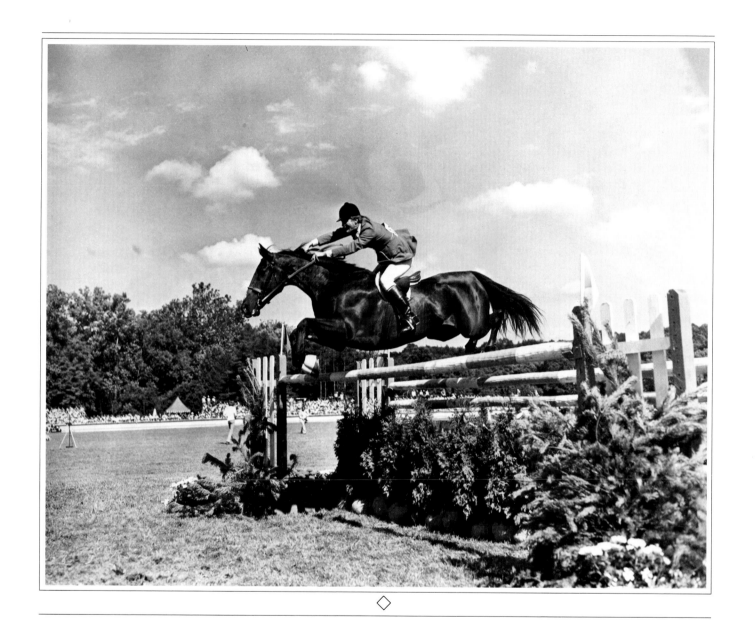

◇

Two of the most recognized competitors in the open jumping world of the '70s and '80s were former Olympic team member Rodney Jenkins and Idle Dice. There were few Grand Prix championships these two did not win, but regardless of final standings they never failed to provide thrilling performances. Idle Dice was a consistent winner until his late teens.

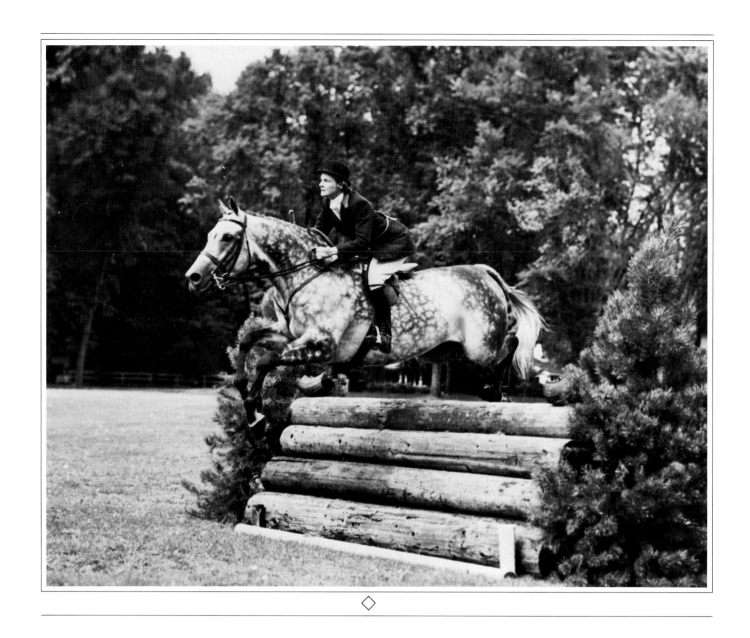

◇

The flawless Charlottesville rider, Ellie Wood Keith Baxter, pilots
Mrs. Parker (Pansy) Poe's Silent Manor at a Gates Mills, Ohio show.
A consummate horsewoman, Ellie Wood has been a competitor for
over thirty-five years and continues to win hunter trials, team
chase events, and any other riding test she and her current hunter,
Ruffy Baxter, can uncover.

*Judge Beverly Gray (left) and rider Kenny Wheeler at the 1971
Warrenton, Virginia, Horse Show.*

*Some things never change! Mrs. E.P. Miller braids the mane of
Forrest Taylor, Jr.'s horse prior to a 1938 show in Lynchburg,
Virginia. Some have described showing as hours of sheer boredom
punctuated by moments of stark terror. The horse's woeful mien
suggests some truth to the adage.*

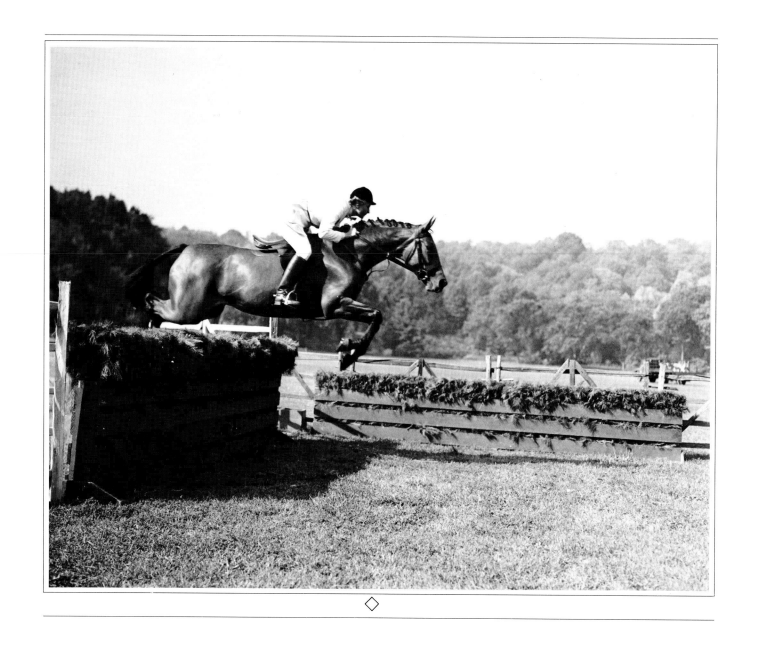

*Claire Lang Miller of Buffalo showing her nice bay over a brush
box at Gates Mills, Ohio, c. 1965.*

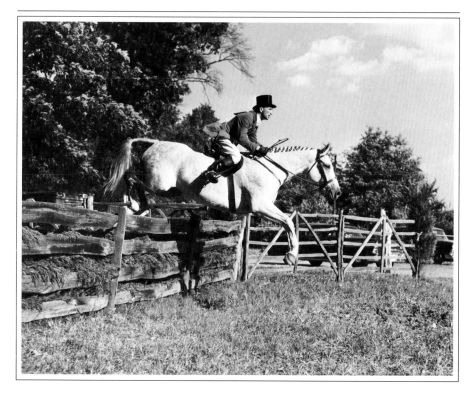

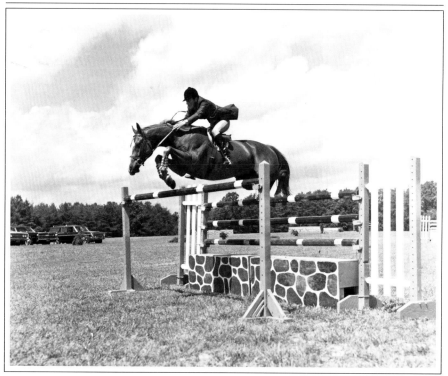

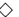

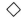

Jack Payne and Spanish Mint, c. 1950.

Juan Rickerhoff, 1970s.

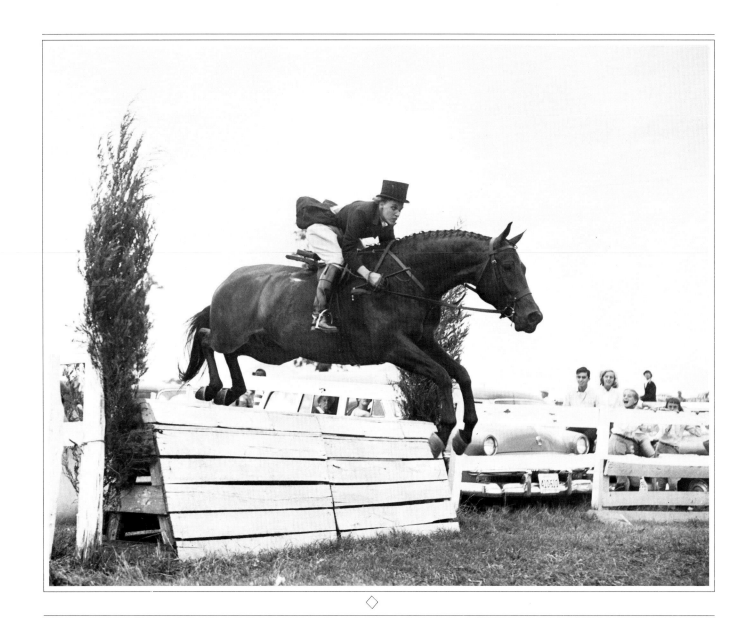

A sure-fire winning combination was Betty Beryl Schenk and the Duke of Paeonian during the 1950s. Owned by John S. Pettibone of Middleburg, Virginia, "The Duke" won more than sixty-five championships and more than 300 reserve championships during his career. Here the pair competes in a Corinthian class at the now-extinct Culpeper, Virginia show. Corinthian rules require formal and precise riding apparel and tack.

IV

Landscapes

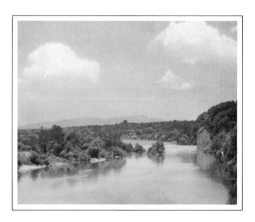

◇

One generation passeth away, and another generation cometh: but the earth abideth forever. The sun also ariseth, and the sun goeth down, and hasteneth to his place where he arose. The wind goeth toward the south, and turneth about unto the north; it whirleth about continually, and the wind returneth again according to his circuits. All the rivers run into the sea; yet the sea is not full; unto the place from whence the rivers come, thither they return again.

ECCLESIASTES
1: 4-7 (King James Version)

*H*awkins' landscape photography is a natural outgrowth of his apprentice years and the equestrian emphasis later in his career. His early study of home and garden landscaping in rural Lynchburg, Virginia, gave him a craftsman's eye and a businessman's taste for countryside portraiture. As his talent for composition developed in regard to horse and rider, so too did his eye for pleasing, yet vibrant, scenic photography.

Marshall believes that each rural scene has a character shaped by the topography and changed by the prevailing mood imparted by climate and weather. It is only natural, then, that Hawkins would be sensitive to the variable demeanor of the countryside. Just as he admires the symmetry of muscle and bone, so too does he revere the contours of the pastoral setting. Here, his expertise in composition comes to the fore. His techniques of framing, knowledge of natural lighting, and love of vistas complement each other to create effects both dramatic and tranquil. How does one view a Hawkins landscape to approximate his sentient eye?

Look first at the edges, the frame of the picture. In all cases, the photograph is naturally framed: by a tree or tree branches, ridges or mountains, flora or fauna, or quite often, by the interplay of light. Where does the viewer's eye first fall on the scene? Does it rest upon a central subject or is it drawn gently across, into, or around the vista? Whatever occurs, it does so because of the natural arrangement of lines, forms, or colors within the scene itself. It is Hawkins' vision, keenly aware of these forces at work on the viewer's eye, that guides him as he composes his portrait. And while modern camera technology may aid him in approximating the image as it is received by the human eye, Marshall somehow enhances it. After a bit, we realize the inadequacy of analysis, and we simply surrender ourselves to the visual pleasure.

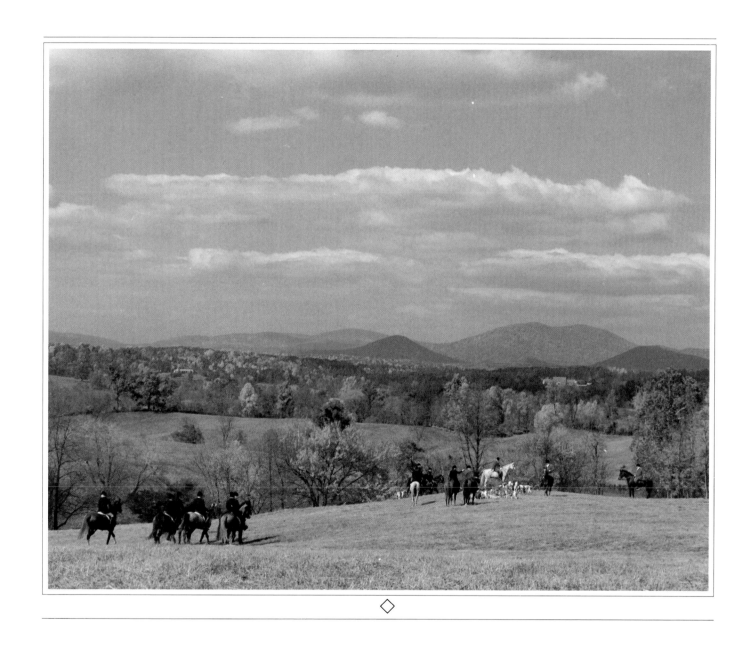

*The Old Dominion Hounds overshadowed by the fall grandeur of
the Blue Ridge Mountains, Virginia.*

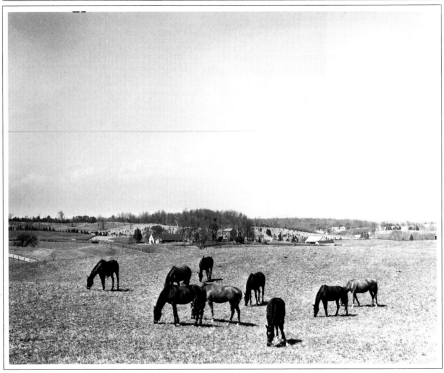

<div style="text-align:center">◇</div>

<div style="text-align:center">◇</div>

Madison County, Virginia. 1940

Northcliff Farm, Rixeyville, Virginia.

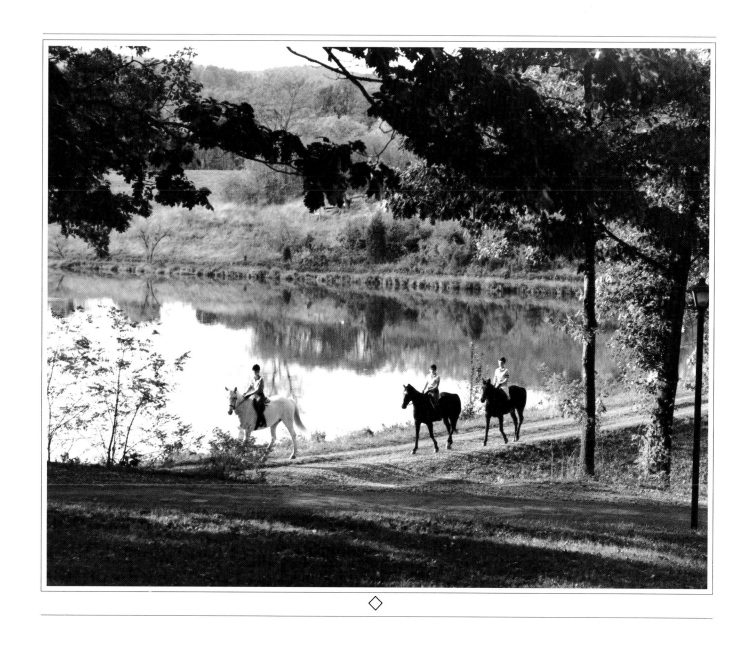

◇

Sweet Briar College, Amherst, Virginia.

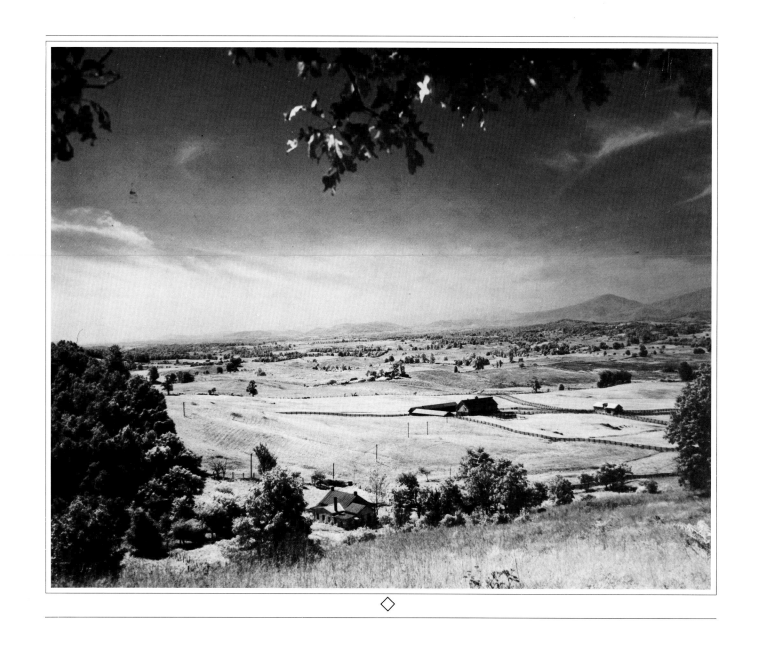

◇

Cobbler Mountain Valley, Hume, Virginia.

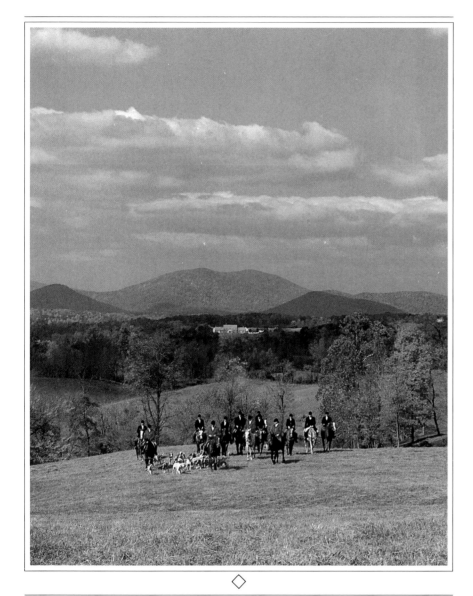

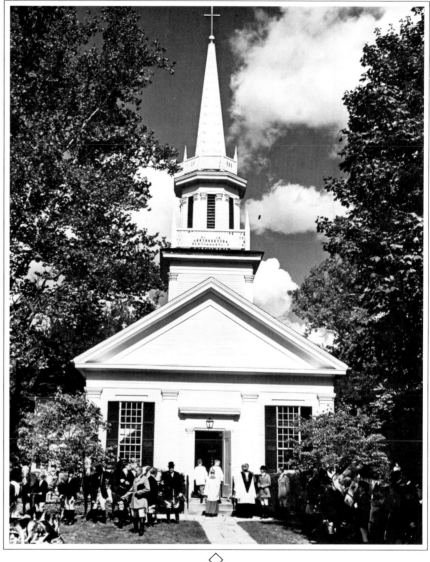

At the core of Virginia foxhunting, Fauquier County provides such marvelous vistas as this for six contiguous hound packs.

The annual Blessing of the Hounds of the Chagrin Valley Hunt has always been done at St. Christopher's-By-The-River Episcopal Church in Gates Mills, Ohio.

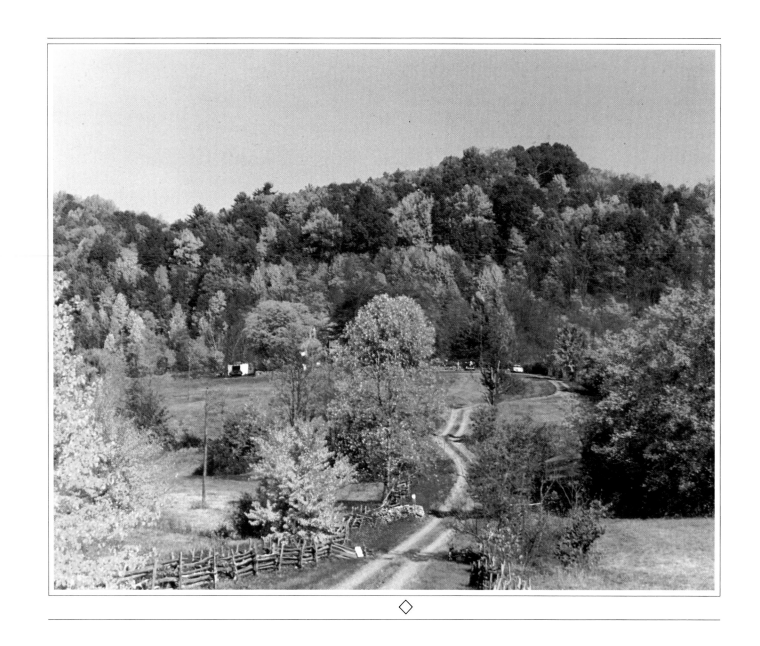

◇

Rappahannock County, Virginia.

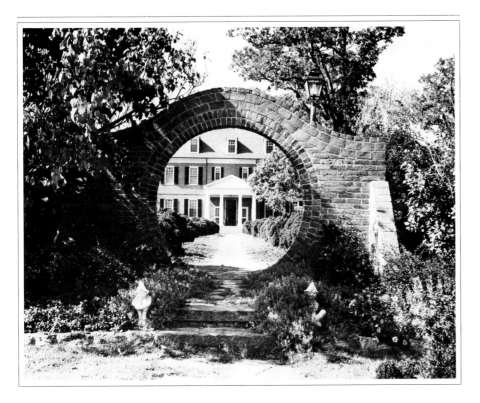

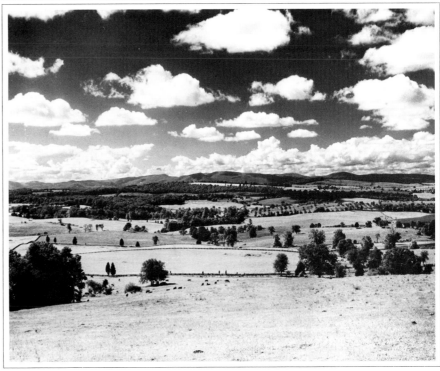

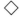

"Moongate," 1939, at Ivy Hill estate in Forrest, Virginia, owned by Herbert Thompson.

The view from Lees Ridge, Warrenton, Virginia.

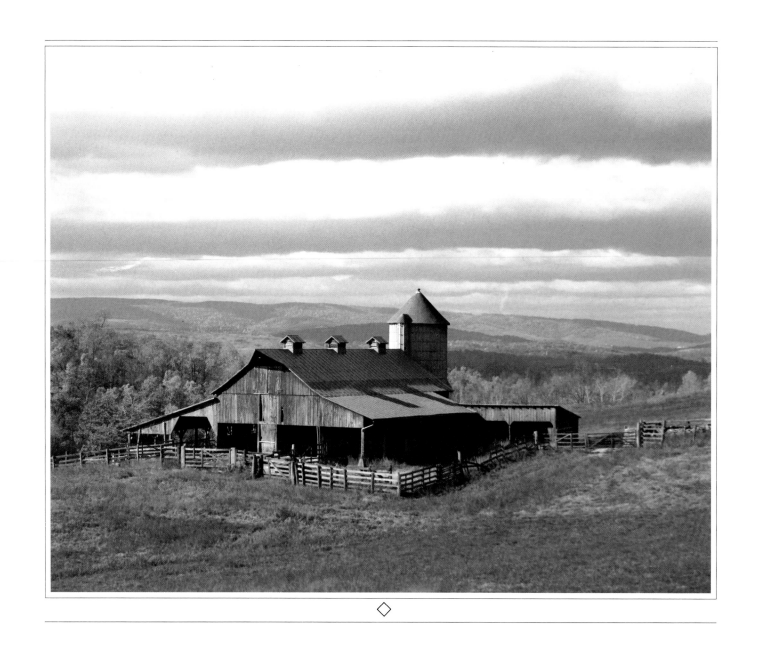

Fauquier County, Virginia.

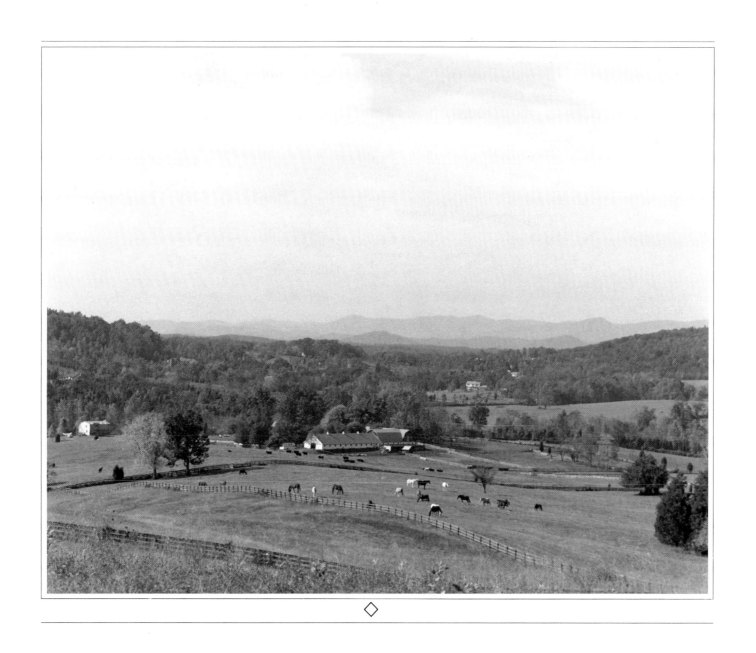

◇

Land Ho Farm, Warrenton, Virginia.

◇

Oakwood Farm, Warrenton, Virginia.

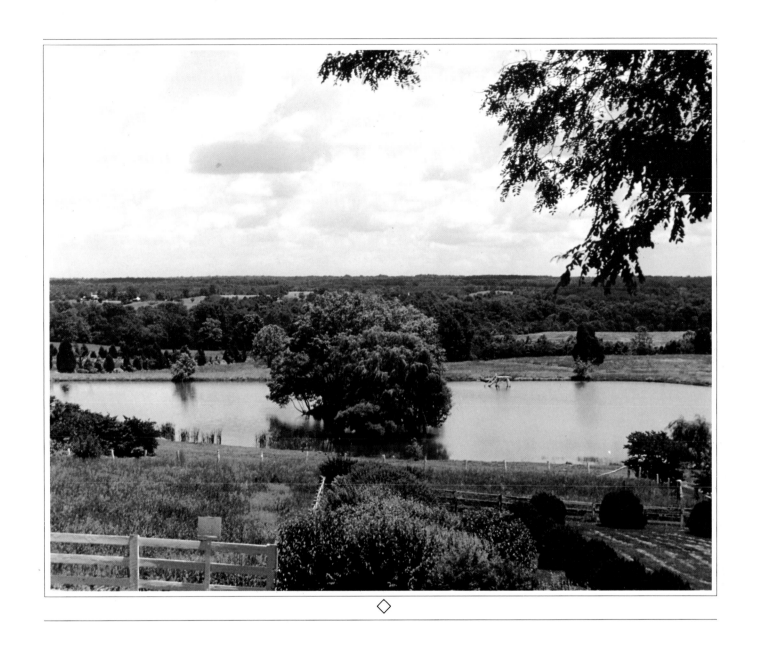

◇

Remington, Virginia.

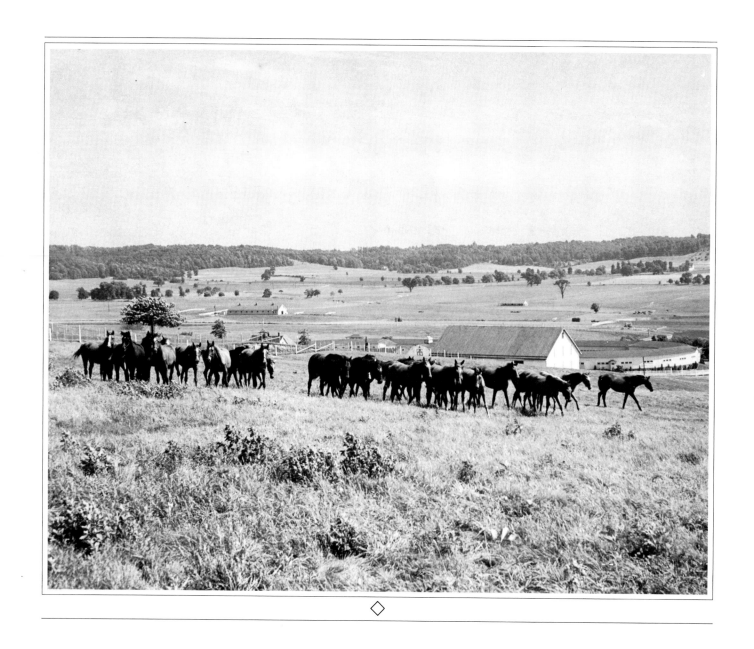

Alfred G. Vanderbilt's Sagamore Farm, Glyndon, Maryland, 1940.

◇

Belvoir Pond near Marshall, Virginia.

◇

Merry Oak, Warrenton, Virginia.

V

Sporting Personalities

◇

You can observe a lot by just watching.

YOGI BERRA

The friendships and acquaintances Marshall Hawkins has cultivated over the years have provided him with the subjects for countless portraits, many of them represented in this chapter. What emerges, however, is not fifty years of personal snapshots, but rather generations of character studies.

Equine sportsmen (regardless of gender) comprise a singular category of humans. Each is seldom a sportsman in a limited sense. Foxhunters oftentimes hunt quail, geese, or elk. Show jump riders may also show terriers or whippets. Race riders foxhunt or hunt rabbits with beagle packs, and event riders pilot steeplechase horses. All of these endeavors include three common denominators: competition, sporting animals, and the rural environment.

But perhaps more importantly, these activities speak to a distinctive human character, a presence, a look if you will. Whether the locale be the hunting field, the steeplechase paddock, a hound show ring, or a polo field, the sportsman's essential persona exists without artifice. Perhaps it is because artifice is not at home among true sportsmen, or perhaps because posturing or poor concentration can have such dire consequences in the field, it is conspicuously absent. Indeed, the players' visages exude competitiveness, sportsmanship, comraderie, and bear naturally weathered countenances. While Hawkins may have chosen each picture with a sale in mind, we can discern the patchwork of sporting life in the various faces, both famous and not, which he has enshrined. What follows, then, is both *Punch* magazine-style caricatures and *People* magazine-style glossies. It makes no matter what sobriquet the viewer applies to each of the portraits herein; they comprise the warp and woof of Marshall's lifelong study. Collectively, they serve as windows to the soul of the sporting personality. Individually, they are, quite simply, fascinating.

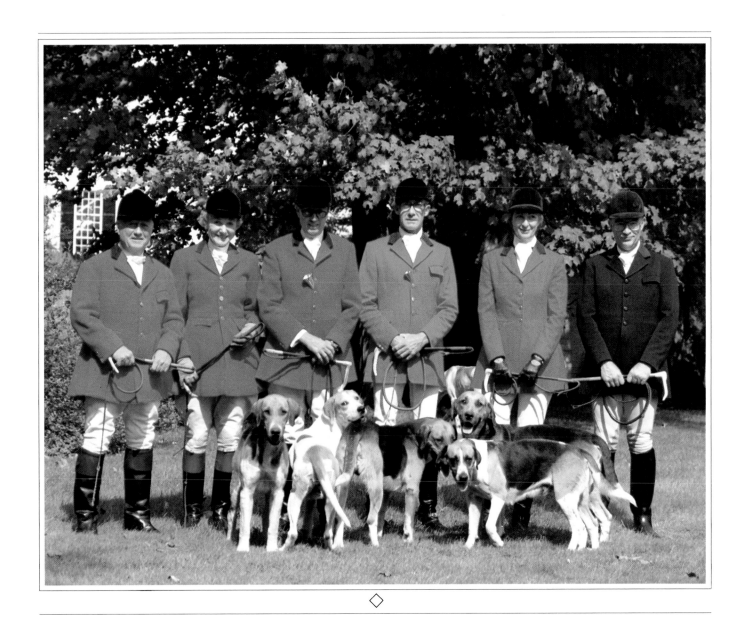

At the 1981 Opening Meet and Blessing of the Hounds of the
Chagrin Valley Hunt: (left to right) Malcolm B. Vilas, Jr., Field
Master; Mrs. Gilbert Humphrey, ex-M.F.H. and Honorary Master;
Robert Y. White, Joint-M.F.H.; Brian Kirkham, huntsman;
Mrs. Shirley Morgan, Joint-M.F.H.; and Richard Van Curen,
field secretary.

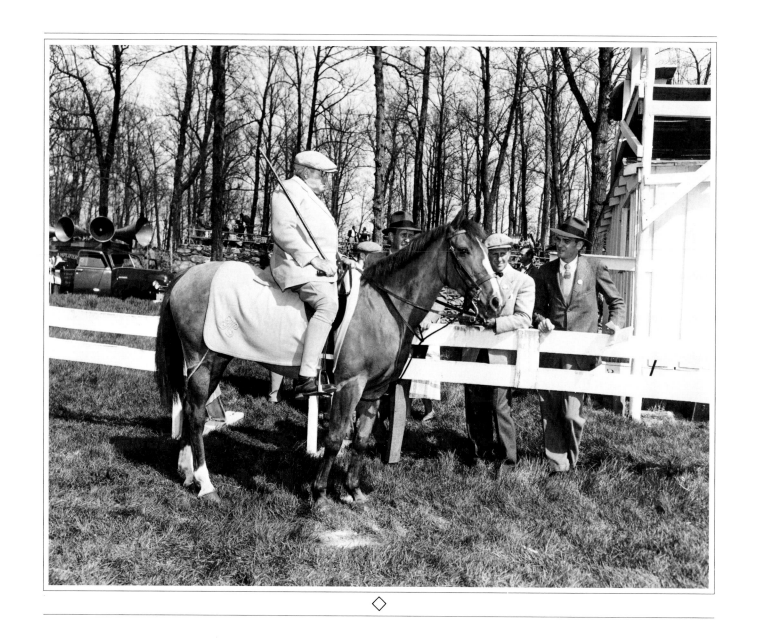

F. Ambrose "Uncle Brose" Clark, on his stable pony at the
Middleburg Races in the 1940s. Clark was a seminal figure in
American steeplechasing for the first five decades of this century.
Scion of the Singer Sewing Machine fortune, Clark's horses could
be found in any winner's circle on the East Coast, and his Kellsboro'
Jack won the 1933 English Grand National. Visible just behind
Clark's horse is Stephen C. Clark, Jr., his nephew and a racehorse
owner in his own right. Popular horseman and race official Brud
Plum is in the soft cap directly in front of the pony.

Longtime friends and clients, Gilbert and Lulu Humphrey of Gates Mills, Ohio, provided Hawkins with a second home for twenty-five years after World War II, enabling him to photograph countless Ohio sportsmen.

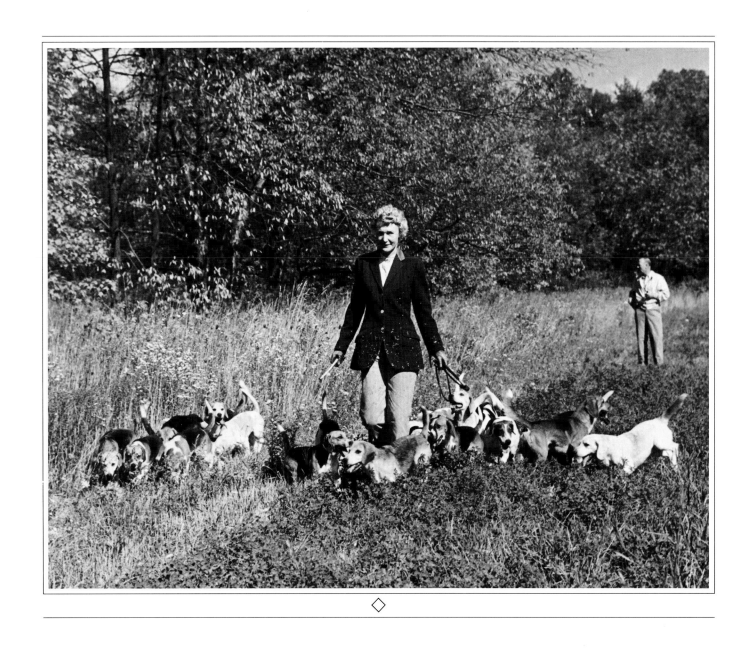

*Lulu Humphrey with her husband hunting her beagle pack near
Cleveland, Ohio.*

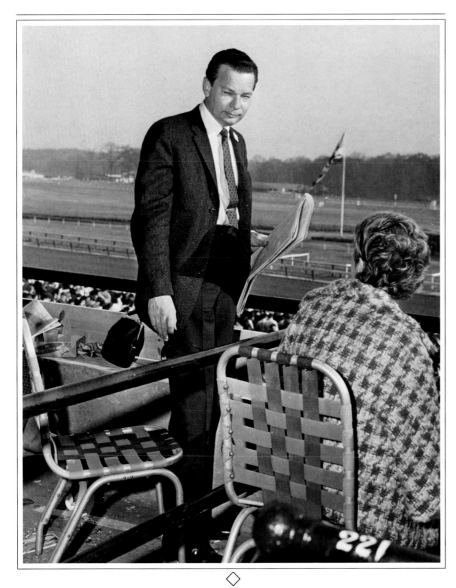

Television journalist David Brinkley attending the Preakness at Pimlico, Maryland.

Mr. and Mrs. Robert H. Crompton, III of Christiana, Pennsylvania at the Oatland Point to Point, 1978. Mr. Crompton has been Joint-Master of Mr. Jefford's Andrews Bridge Hounds since 1968. Kathleen, the daughter of famed steeplechase rider Rigan McKinney, is a former Master of the Vicmead Hunt.

Robert Y. White and his wife, Connie, of Gates Mills, Ohio. White recently retired after 26 years as the respected Master of the Chagrin Valley Hunt. He continues to serve as trustee of the hunt servants' benefit fund of the Masters of Foxhounds Association of America.

The late Middleburg, Virginia, country doctor Robert McConnell and his wife, Carmen. Physician to horsemen for over thirty years, McConnell was a familiar figure at Virginia horse events.

At the Rappahannock Hunt Ball (left to right) are: Major and Mrs. William Tucker (USAF) and Rappahannock Joint-Master John R. Debergh. Hunt balls are formal dinner dances sponsored as fund-raisers by foxhunt clubs. The foxhunter's evening scarlet is worn only on these formal occasions, and it sports the official brass button insignia and hunt colors on the coat collar and lapel facings.

At a 1987 Orange County Hunt hunter trial is Sen. John Warner (R-Va.) and Virginia Guest, daughter of former ambassador to Ireland, Raymond Guest.

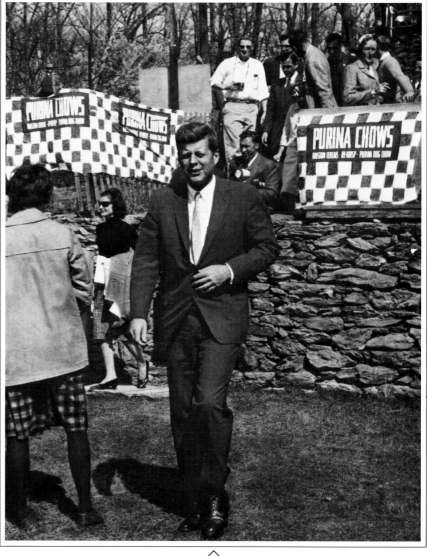

◇

◇

On the right is Miss Charlotte Noland, founder and, for forty-seven
years, the headmistress of Foxcroft School in Middleburg, Virginia.
An indomitable force in the lives of generations of young women,
Miss Charlotte created an atmosphere where excellence issued
from strong, self-disciplined character and uncluttered thinking.
At Foxcroft, riding was a required part of the curriculum and
uniforms were the order of the day. During World War II, Miss
Charlotte established a military environment in which the students
were required to drill, act as enemy plane spotters, and subject
themselves to frequent military inspections by regular Army
personnel, such as this officer.

Never before published, this picture shows President John F.
Kennedy and Mrs. Kennedy (dark glasses) at the Middleburg Races
in1962. Later on this same day as the president was leaving the
course, he stopped briefly and joined other "railbirds" to watch
the running of a steeplechase race, totally unnoticed by those
standing next to him.

Many of Hawkins' first equestrian subjects were among this senior class of E.C. Glass High School in Lynchburg, Virginia, c. 1940.

At Bath, Ohio, in 1976: (left to right) Mr. and Mrs. Hugh Hunter;
Mrs. Raymond Firestone, Joint-M.F.H. of Lauray Hunt; Mr. John
Bowles; and Mr. Firestone, Joint-M.F.H. of Lauray Hunt. Masters
of their own fox and drag hunting pack, the Firestones later moved
to Southern Pines, North Carolina, where they are now regular
supporters of the Moore County Hounds.

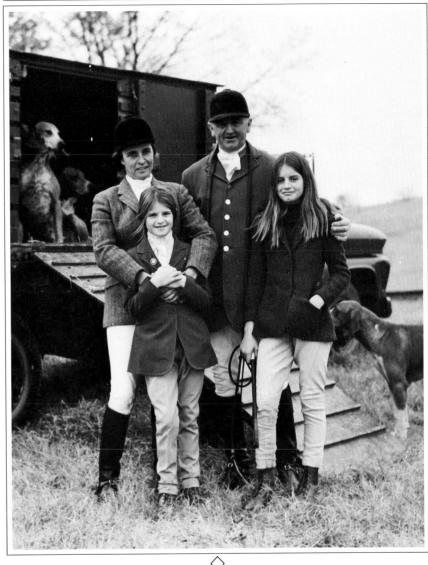

Angie Saunders Rogers and husband, Robert "Buzz" Rogers, 1951.

Huntsman Melvin Poe and wife, Peggy, with their two daughters, Bridget (right) and Patty.

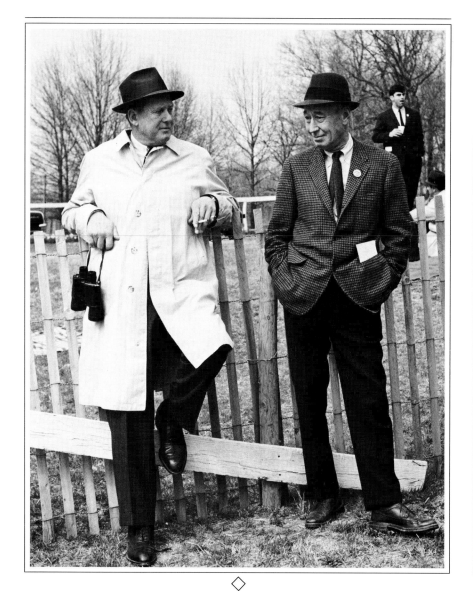

The late James L. Wiley (left) and George Robert Slater serving as race officials at Middleburg in 1964. Wiley was a respected thoroughbred breeder and bloodstock agent, and Slater, now in his eighties, was a former steeplechase rider who still officiates at local races.

President and Mrs. Reagan come to horse country. Sen. John Warner and his former wife, Elizabeth Taylor, welcome the Reagans to his Atoka Farm and the annual Republican Country Supper.

◇

*Two top Virginia thoroughbred breeders and agents, James L. Wiley
(left) and J. North Fletcher, view a crop of Virginia yearlings before
the summer sales in 1962. On the far left is Wiley's daughter,
Langhorne, and in the center is Mrs. Fletcher.*

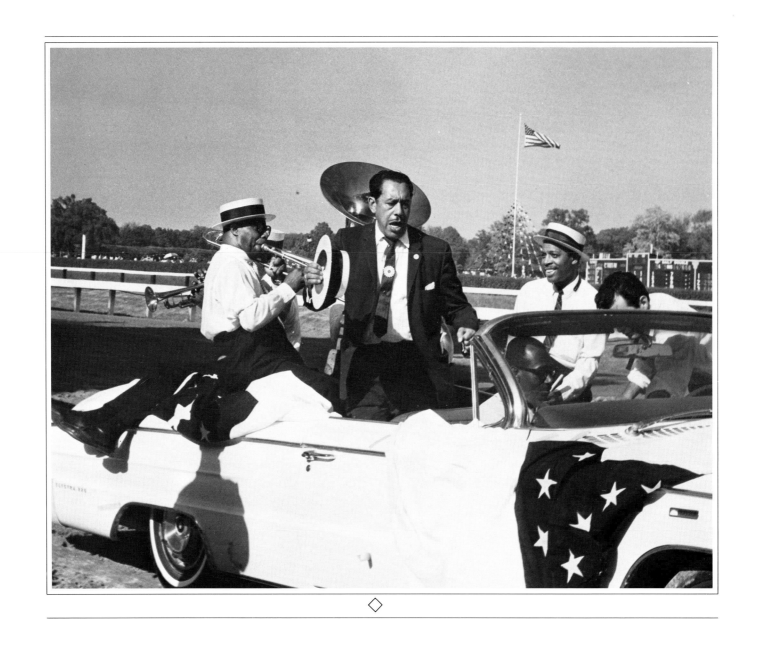

*Famed band leader Cab Calloway at the Pimlico race track in
Maryland, 1978.*

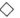

*Virginia sporting personalities Mr. and Mrs. William Haggin Perry.
A former Master of the Keswick Hunt, Perry has been a successful
owner and breeder of such top-level thoroughbred racehorses as
Coastal and the ill-fated Swale, winner of the Kentucky Derby who
died of an apparent blood clot in 1984 one week after winning
the Belmont Stakes.*

*Springtime hound shows provide Masters and huntsmen annual
opportunities to display their best hounds in competition and to
inspect others' hounds for potential breeding purposes. Here, W.W.
Brainard, Jr., in white kennel coat, then-Master of the Old
Dominion Hounds, shows one of his bitches to judges (left) Major
Gerald A. Gundry, M.F.H. of the Duke of Beaufort's (G.B.) and
Major William M.F. Bayliss, ex-M.F.H. of the Deep Run Hunt.*

The 1950 Chagrin Valley Hunt Horse Show Committee. (left to right): Rear—Pam Firman; Robert Y. White, Joint-M.F.H.; Mrs. F.V. Davis; Ringmaster Homer Everett; Mrs. Robert White; Courtney Burton, Joint-M.F.H. Front—Mrs. Courtney Burton; Mrs. Gilbert Humphrey, Joint-M.F.H.; Mrs. Homer Everett; Mrs. Ralph Perkins.

Liz Whitney Tippett on her Llangollen Farm with farm children,
ubiquitous dogs, and pet pig.

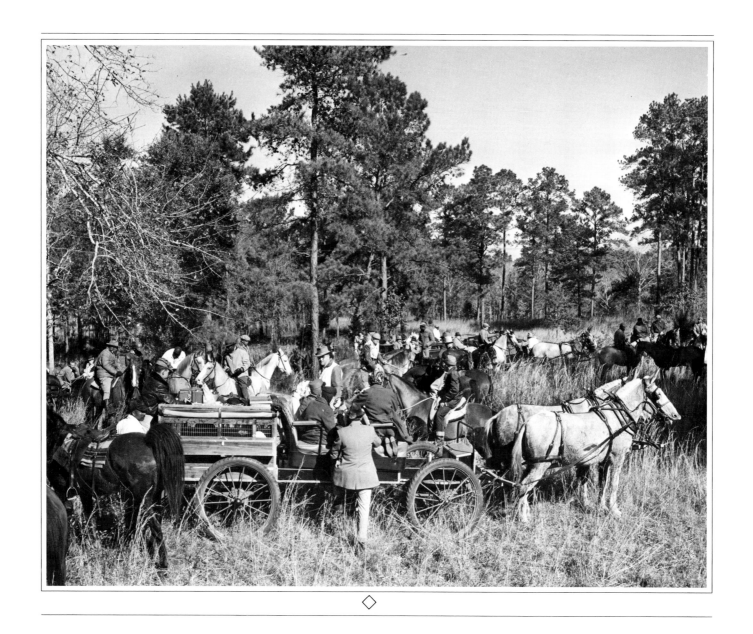

The Amateur Owner/Trainer Field Trials for Sporting Dogs,
Thomasville, Georgia, c. 1955. Nestled deep in the piney woods of
quail territory, these shooting wagons carry the hunting dogs and
shooters while some hunters ride on horseback. The field trial
competition does not involve the shooting of quail, but rather
simulates actual hunting conditions.

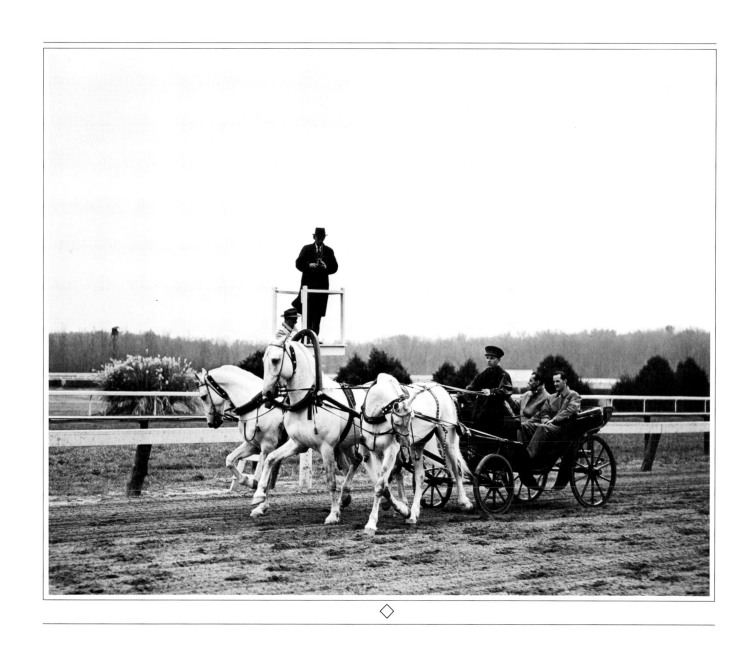

A Russian troika carriage parading before the Preakness at Pimlico
Race Course in the 1960s.

◇

*Awarding the 1947 Virginia Gold Cup steeplechase trophy to
winning owner, Richard Stokes (center, with hand to hat) is
Warrenton Hunt M.F.H. Henry Pool. The focal point of this
marvelous composition, however, is the beguiling towhead in the
center, straining to catch a glimpse of the famed trophy cradled in
the arms of the jockey. The viewer's eye starts with her, is drawn by
her gaze to the trophy and thence to the principals of the ceremony.
After a pause, it is captured by the circle of spectators and, as if
by centrifugal force, is spun along the rim of onlookers.*

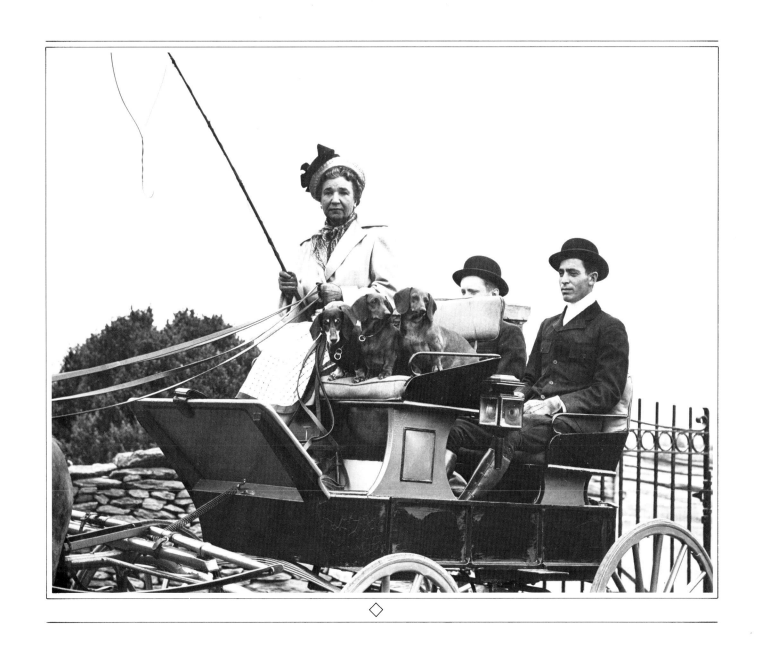

◇

The incomparable Mrs. Robert C. Winmill driving one of her more than 100 coaches. A former Master of the Warrenton Hunt, Mrs. Winmill was an accomplished sidesaddle foxhunter as well as a champion in coaching competitions.

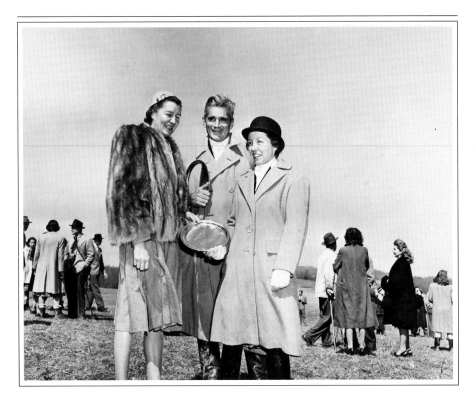

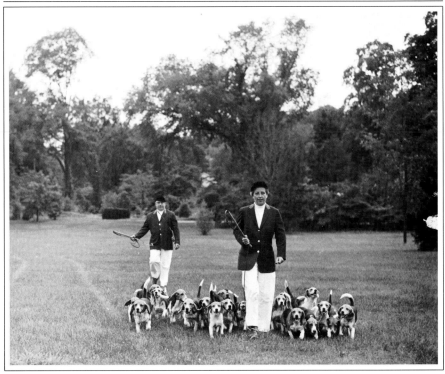

(Left to right): Mrs. Amory (Dolly) Carhart, Gerald Webb, Mrs. Maximilian (nee Sally Spilman) Tufts. Mrs. Carhart was wife of the former Warrenton Hunt Master while Mrs. Tufts is a current Joint-Master. Webb, founding editor of The Chronicle of the Horse and great-grandson of Jefferson Davis, was dragged to his death while riding in a steeplechase race.

Mrs. Myron E. Merry, Master of Beagles, parades her Merry Beagles pack at Gates Mills, Ohio. Following her is whipper-in Harold Bywaters. Beagles hunt cottontail rabbit or hare while the followers keep up on foot. A good beagle hunt is exhilarating, frantic, colorful, and exhausting.

Novelist William Faulkner (in top hat) hunting with Molly McIntosh Nicoll at the Farmington Hunt in the 1950s.

Acknowledgements

No single endeavor such as this book comes to fruition without encouragement and assistance from many quarters, sometimes offered over many years. To the following is extended our sincere gratitude;

Lucille Hawkins, whose steady hand and delicate brush have for many years added a whole new dimension to Hawkins' photographs. Her hand-tinted photos grace the opening page of each section in the book;

George L. Ohrstrom, Jr., eminent sportsman whose initial impetus and ongoing support allowed this book to be published;

David Hugh Dillard, who provided Marshall with personal and legal support at the start of his career;

Bob Miller of Gordonsville, Virginia, a supreme cameraman who kept Hawkins' 70 mm combat camera in proper order for 20 years;

Gilbert and Lulu Humphrey, who provided Marshall with an Ohio base for more than 25 years;

Mr. and Mrs. Raymond Firestone, close friends and benefactors for 15 years;

Kenny and Sallie Wheeler of Keswick, Virginia. More loyal customers and friends cannot be found;

Bruce Sundlun, who came to Hawkins' aid when he was seriously hurt, even though Marshall barely knew him;

Mrs. Parker Poe, who provided Marshall with many opportunities to photograph field trials and shootings in Georgia;

To the innumerable hunt masters and huntsmen who invited Hawkins to hunting meets, allowed him to follow on foot, and taught him the art of foxhunting photography;

Liz Whitney Tippett, who started it all. Marshall has known only kindness and loyalty from her;

Sally Young, Jackie Onassis, Eve Fout, Nancy Lee, Mary Coker, Kitty Slater, Mead Stone, and Peggy Haight, all shanghaied volunteers who helped to edit and identify pictures, proofread copy, and provide sustaining encouragement.

190

Index